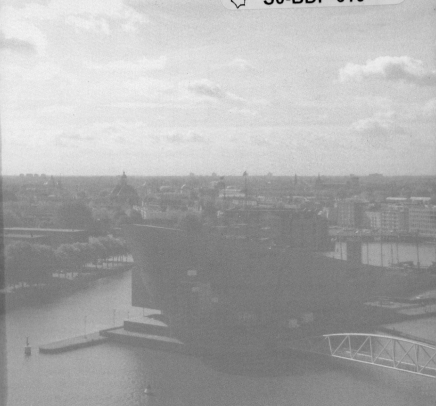

S0-BDP-619

AMSTERDAM
architecture & design

Edited by Sabina Marreiros
Written by Matthias Breithack
Concept by Martin Nicholas Kunz

teNeues

content

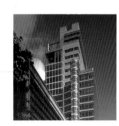

introduction 6
01 De taart van m'n tante 9
02 Booster Pumstation East 10

to see . living

03 Silodam 14
04 Hoogte Kadijk and Laagte Kadijk 16
05 Hall of Residence Sarphatistraat 18
06 Borneo Housing 20
07 Hoop, Liefde en Fortuin 22
08 Kavel 37 24
09 Patio Malaparte 26
10 KNSM- and Java Eiland 28
11 Waterdwellings 30
12 Dukaat 32
13 Hoytema Residence 34
14 Timorplein / Borneodriehoek 36
15 Watervillas Almere 38

to see . office

16 Loftice 40
17 Pakhuis Amsterdam 42
18 Eurotwin Business Center 44
19 Ogilvy Group Nederland bv 46
20 Apollo Building 48
21 World Trade Center Amsterdam 50
22 Philips Headquarters 52
23 ING Group Headquarters 54
24 Office Building Oficio 58
25 World Trade Center Schiphol 60
26 La Defense Almere 62

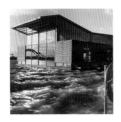 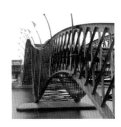

to see . culture & education

to see . public

27	Arcam Architectural Center	64
28	New Metropolis	66
29	Anne Frank Museum	68
30	Depot Scheepvaart Museum	70
31	Bredero College School Extension	72
32	Primary School Horizon	74
33	Nicolaas Maesschool	76
34	Concert Hall Renovation	78
35	Visitor Center IJburg	80
36	Emma Church	82
37	Living Tomorrow Pavilion	84
38	School of Business	86

39	Station Island	88
40	Bicycle Storage	90
41	IJburg Bridges	92
42	Borneo Sporenburg Bridges	94
43	Piet Hein Tunnel	96
44	Evenementen Brug	98
45	Zorgvlied Cemetery	100
46	Bus Station Hoofddorp	102

content

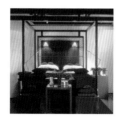

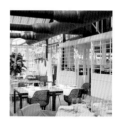

to stay . hotels

47	Blakes Hotel	106
48	Hotel Seven One Seven	108
49	Kien Bed and Breakfast	110
50	Hotel de Filosoof Renovation	112
51	Hotel V	114
52	Hotel Arena	116

to go . eating, drinking, clubbing

53	Brasserie Harkema	120
54	Supperclub Amsterdam	122
55	Noa Noodles Of Asia	124
56	Nomads	126
57	Morlang	128
58	Jimmy Woo	130
59	Plancius	134
60	Blender	136
61	Three Restaurants	138
62	Vakzuid	140
63	Restaurant De Kas	142

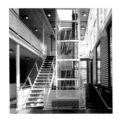

to go . wellness, beauty & sport

to shop . mall, retail, showrooms

64	Cinema Het Ketelhuis	144
65	Cinecenter	146
66	De Toekomst, A.F.C. Ajax	148
67	Sports Medical Center Olympiaplein	150
68	Amsterdam ArenA	152

69	Baden Baden	156
70	A-Markt	158
71	Mac Bike	160
72	Jan Jansen Shop	162
73	Rituals	164
74	Australian	166
75	Art and Fashion	168
76	Weekend Company	170
77	Fishes	172
78	Shoebaloo	174
79	Lairesse Apotheek	176
80	Villa ArenA	178

index
Architects / Designers / Districts	180
Photo Credits / Imprint	186
Map / Legend	188

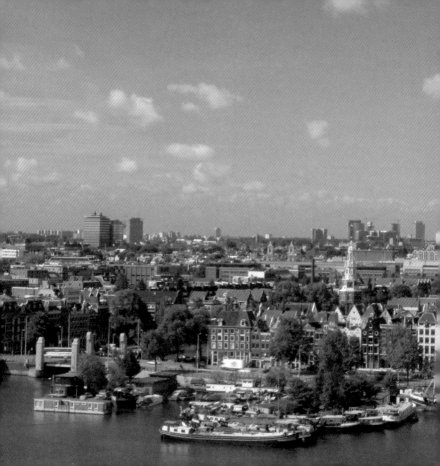

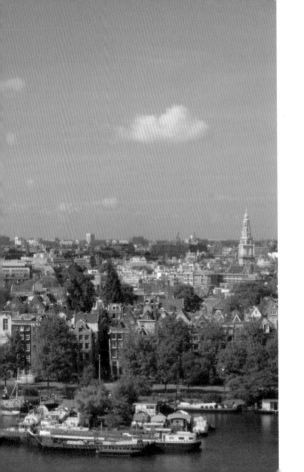

introduction

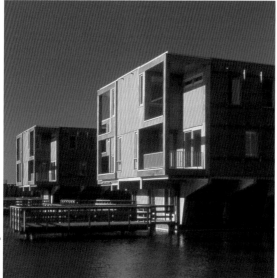

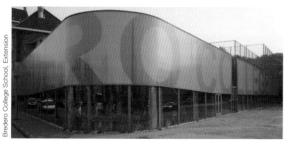

Waterdwellings

Bredero College School, Extension

The old town of Amsterdam, the "Venice of the North", is well-known for its broad-minded atmosphere. Lifestyle and design trends develop in the shops, galleries and clubs, usually situated in the listed houses along the canals. At the same time, the municipal development projects, such as the revitalization of the former dockland area on Borneo, have produced a real building boom. A continuously high demand for residential and trade areas is expected for the future as well. A constructional and infrastructural union of towns will be developed in the conurbation up to Rotterdam—in the so-called "Randstad". Against this background, the Netherlands are taking top position in the international architecture and design scene.

01. De taart van m'n tante
Noam Offer, Jaqu Jansen,
Siemon de Jong

2003
Ferdinand Bolstraat 10/part
De Pijp

www.detaart.com

Die Altstadt Amsterdams, das „Venedig des Nordens", ist bekannt für eine aufgeschlossene Atmosphäre. In den Läden, Galerien und Clubs der zumeist denkmalgeschützten Grachtenhäuser entwickeln sich Lifestyle- und Design-Trends. Gleichzeitig sorgen städtische Entwicklungsprojekte, wie die Revitalisierung der ehemaligen Hafenanlage auf Borneo, für eine regelrechte Baueuphorie. Auch in Zukunft wird ein anhaltend hoher Bedarf an Wohn- und Gewerbefläche erwartet. Tatsächlich soll im Ballungsgebiet bis nach Rotterdam – in der so genannten Randstad – ein baulicher und infrastruktureller Städteverbund entstehen. Vor diesem Hintergrund nimmt Holland einen Spitzenplatz in der internationalen Architektur- und Designszene ein.

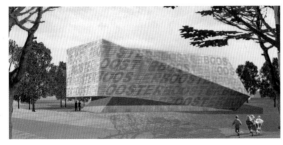

02. Booster Pumstation
Juliette Bekkering Architecten
DWR Ingenieursbureau (SE)

2005
Zuiderzeeweg 10
Zeeburgereiland

www.bekkeringarchitecten.nl

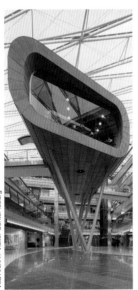

Villa ArenA / Visitor Center IJburg

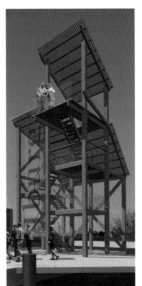

La vieille ville d'Amsterdam, la « Venise du Nord », est réputée pour sa franchise. Des tendances de style de vie et de design se développent dans les les boutiques, galeries et clubs, installés dans des maisons classées monument historique qui bordent les canaux. En même temps, les projets de développement de la ville, comme la revitalisation des anciennes installations portuaires de Borneo, alimentent une véritable euphorie pour la construction. Un besoin de logements et surfaces commerciales devrait croître à l'avenir. Une alliance urbaine pour l'infrastructure et la construction doit se former dans cette région concentrée qui s'étend jusqu'à Rotterdam, dans ce qu'on appelle la « Randstad ». Ainsi les Pays-Bas occupent une place de choix sur la scène d'architecture et de design internationale.

Spui 14-16 Amsterdam
☎ Boekhandel: 020-6226248
☎ Nieuwscentrum: 020-6242972

Openingstijden Boekhandel

Maandag	11.00 - 18.00
Dinsdag	9.30 - 18.00
Woensdag	9.30 - 18.00
Donderdag	9.30 - 21.00
Vrijdag	9.30 - 18.00
Zaterdag	9.30 - 18.00
Zondag	12.00 - 17.30

Openingstijden Nieuwscentrum

Maandag t/m Zaterdag	8.00 - 20.00
Zondag	10.00 - 18.00

Internet
www.athenaeum.nl
info@athenaeum.nl

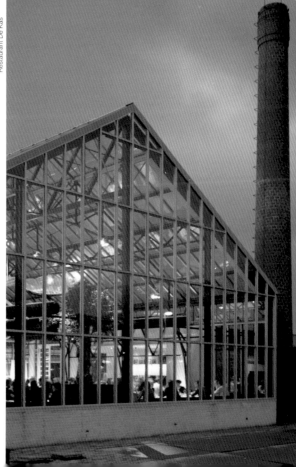

El casco antiguo de Amsterdam, la "Venecia del Norte", es conocido por su espíritu abierto. En los negocios, galerías y clubs de casas de canal "Grachent" generalmente declaradas monumento nacional, se desarrollan modernos estilos de vida y tendencias de diseño. Al mismo tiempo los proyectos de desarrollo urbanístico, como la revitalización de los muelles del puerto de antaño en Borneo, han dado lugar a una real euforia de construcción. También para el futuro se prevé la gran necesidad de áreas habitacionales y comerciales. Efectivamente se está planificando una interconexión urbana de construcción e infraestructura desde el centro de aglomeración hasta Rotterdam, en la llamada "Randstad". Frente a este trasfondo Holanda figura a la cabeza del quehacer internacional de arquitectura y diseño.

to see . living
office
culture & education
public

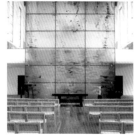
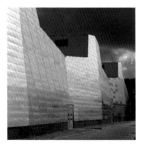
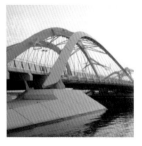
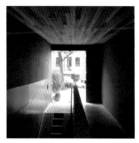
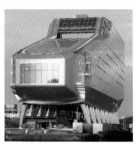
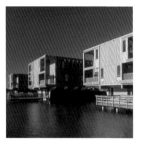
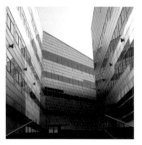
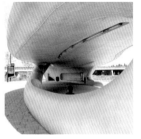

Silodam

MVRDV
Pieters Bouwtechniek (SE)

2002
Silodam
Center

www.silodam.nl
www.mvrdv.archined.nl

The facade of the building has been modeled on the residential granaries in the neighborhood. The individual houses consisting of 4 to 8 flats each, which are individually designed inside and outside, look as if they were stacked containers. The access stage pushes underneath the building and ends on a large terrace.

In seinem Äußeren ist das Gebäude den ebenfalls bewohnten Getreidesilos der Nachbarschaft nachempfunden. Wie gestapelte Container wirken die innen und außen individuell gestalteten Einzelhäuser aus je 4–8 Wohnungen. Der Zugangssteg schiebt sich unter das Gebäude und endet auf einer großen Terrasse.

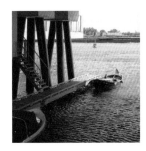

La façade du bâtiment a été modelée sur les silos à grain résidentiels du voisinage. Les maisons individuelles de 4 à 8 logements chacune, conçues individuellement à l'intérieur et à l'extérieur, ressemblent à des containers superposés. La passerelle d'accès se glisse sous le bâtiment et finit sur une grande terrasse.

En su aspecto exterior el edificio ha sido concebido para seguir el estilo de los silos de cereales adyacentes, que también están habitados. Las casas individuales que consisten de 4-8 departamentos, cuya presentación por fuera y dentro son individuales, parecen containers apilados. La vereda de acceso va bajo el edificio y termina en una gran terraza.

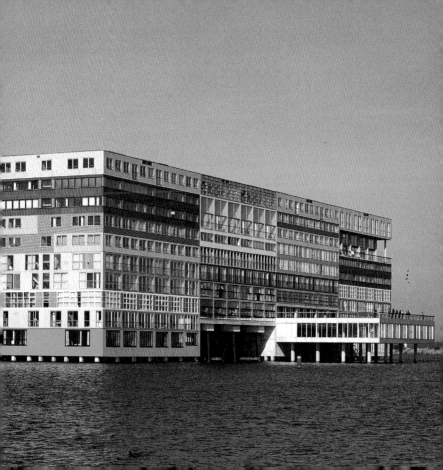

Hoogte Kadijk
and Laagte Kadijk

Claus en Kaan Architecten

1998
Hoogte Kadijk 21, 28 /
Laagte Kadijk 12-14, 30-33
Center

www.clausenkaan.nl

Whilst the narrow buildings in Hoogte Kadijk adapt to the vertical rhythm of the street, the wider facades in Laagte Kadijk render the absence of this historical context all the more clearly. The four buildings pick up the type of housing in the surroundings. The entrances give them their own character.

Während sich die schmalen Gebäude in Hoogte Kadijk dem vertikalen Rhythmus der Straße anpassen, machen die breiteren Fassaden in Laagte Kadijk das Fehlen dieses historischen Kontextes umso deutlicher. Die vier Gebäude greifen den Wohntypus der Umgebung auf. Die Eingänge verleihen ihnen einen eigenen Charakter.

Alors que les bâtiments étroits de Hoogte Kadijk s'adaptent au rythme vertical de la rue, les larges façades de Laagte Kadijk soulignent l'absence de ce contexte historique. Les quatre bâtiments reprennent le type de logement des environs. Les entrées leur confèrent un caractère individuel.

Mientras que los edificios angostos en Hoogte Kadijk se asemejan al ritmo vertical de la calle, las amplias fachadas en Laagte Kadijk subrayan la ausencia de este contexto histórico aún más. Los cuatro edificios hacen suyo el tipo de vivienda de su entorno. Los accesos le otorgan carácter propio.

Hall of Residence Sarphatistraat

Claus en Kaan Architecten

2002
Sarphatistraat 143–159
Center

www.clausenkaan.nl

The student hostel is part of a kind of town repair which aims at restoring the spatial edges given up in the sixties. The "dancing" windows interpret the decoration of the years of rapid industrial expansion in the Netherlands, whereas the remaining order embraces the buildings of the sixties.

Das Studentenwohnheim ist Teil einer Art Stadtreparatur, welche die Wiederherstellung der in den sechziger Jahren aufgegebenen Raumkanten zum Ziel hat. Die „tanzenden" Fenster interpretieren das Dekor der holländischen Gründerzeit, während ihre noch ablesbare Ordnung den Bauten der sechziger Jahre huldigt.

La résidence universitaire fait partie d'un type de travaux urbains dont l'objectif est de rétablir les espaces délimités abandonnés dans les années 60. Les fenêtres « dansantes » interprètent le décor de la période de développement économique rapide aux Pays-Bas, alors que leur ordre restant rejoint les bâtiments des années 60.

El Hogar Estudiantil es parte de una especie de arreglo urbano, que tuvo como meta la renovación de lugares marginales desechados en los años sesenta. Las ventanas "danzantes" interpretan la decoración de la época fundadora holandesa, mientras que su ordenamiento aún perceptible recuerda a las construciones de los años sesenta.

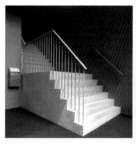

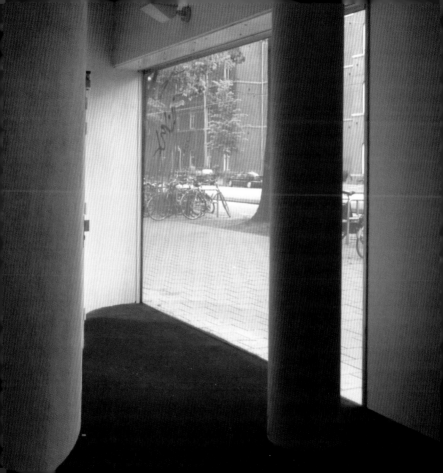

Borneo Housing

De Arichtektengroep
Smit's Bouwbedrijf (SE)

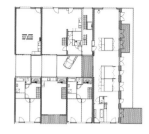

1999
Stuurmankade /
Scheepstimmermanstraat
Borneo-Sporenburg

www.architectengroep.com

The parking space next to the entrance door so typical for Borneo is conspicuous by its absence in this building. A street on the inside separates the parking spaces from the street area. At one narrow side the residential building appears to be cut apart: Relieved of the massive shell, the glass boxes rise dynamically into the surroundings.

Den für Borneo typischen Autostellplatz neben den Eingangstüren sucht man bei diesem Gebäude vergeblich. Eine Straße im Innern trennt die Parkflächen vom Straßenraum. An einer Schmalseite erscheint das Wohnhaus wie aufgeschnitten: Befreit von der massiven Hülle ragen Glaskisten dynamisch in die Umgebung.

La place de parking à côté de la porte d'entrée, typique de Borneo, est introuvable dans ce bâtiment. Une rue intérieure sépare les aires de stationnement de la voie publique. Sur un côté étroit, la maison d'habitation apparaît comme découpé : libérés des enveloppes massives, les blocs de verre se dressent de manière dynamique aux environs.

Los estacionamientos para coches típicos de Borneo, ubicados al lado de las puertas de entrada, aquí se buscan en vano. Una calle en el interior separa los aparcamientos de la calle en el exterior pública. En una parte estrecha la casa habitación parece estar abierta: liberada de la envoltura maciza, cajas de vidrio se elevan dinámicamente al entorno.

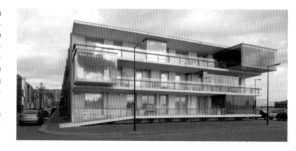

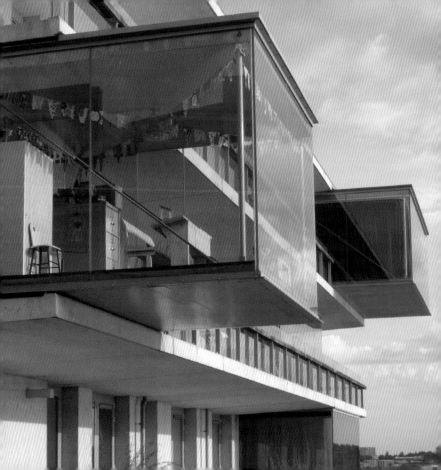

Hoop, Liefde en Fortuin

Rudy Uytenhaak Architectenbureau BV, Rudy Uytenhaak,
Engbert van der Zaag
Pieters Bouwtechniek (SE)

2002
Rietlandenterras 2-54 /
Borneolaan 1-327
Borneo-Sporenburg

A unique mixture of flats, social security office, day-nursery and offices characterizes this large-scale building complex. It bears the name of three windmills which stood at this point one time. The monumental northern facade made of Norwegian marble was produced in co-operation with the artist Willem Oorebeek.

Eine einzigartige Mischnutzung aus Wohnungen, Sozialamt, Kinderhort und Büros kennzeichnet den großmaßstäblichen Gebäudekomplex. Er trägt den Namen dreier Windmühlen, die hier einst standen. Die monumentale Nordfassade aus norwegischem Marmor entstand in Zusammenarbeit mit dem Künstler Willem Oorebeek.

Un mélange unique de logements, d'un centre social, d'une garderie et de bureaux caractérise ce complexe de bâtiment à grande échelle. Il porte le nom de trois moulins à vent, qui s'y trouvaient autrefois. La façade nord monumentale, en marbre norvégien, a été créée en collaboration avec l'artiste Willem Oorebeek.

Una mezcla única de departamentos, oficina de asistencia social, guardería infantil y oficinas, caracteriza el complejo de edificios a gran escala. Lleva el nombre de tres molinos de viento, que alguna vez existieron aquí. La monumental fachada norte de mármol noruego se construyó con la colaboración del artista Willem Oorebeek.

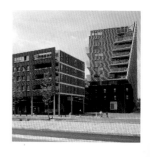

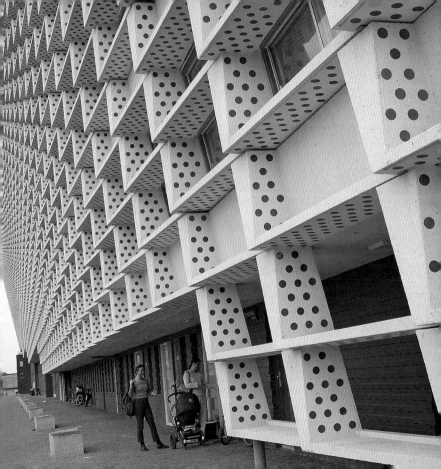

Kavel 37

Heren 5 architecten

2000
Scheepstimmermanstraat
Borneo-Sporenburg

www.heren5.nl

In its reddish-brown and rusty appearance, the facade made of perforated cor-ten steel calls the harbor to mind. It offers the residents privacy, but gives them an unobstructed view. Floors made of glass in the upper flat permit daylight to flood right down to the ground floor and illuminate the entrance area through the roof.

Rotbraun und rostig erinnert das Fassadenkleid aus gelochtem Corten-Stahl an den Hafen. Es bietet den Bewohnern Privatsphäre und ermöglicht ihnen ungehinderten Ausblick. Glasböden in der oberen Wohnung bringen Tageslicht bis ins Erdgeschoss und belichten den Eingangsbereich über das Dach.

Par son apparence rouge-brun et rouillé, la façade en acier corten perforé rappellent le port. Elle offre aux habitants une sphère privée, mais leur donne une vue dégagée. Les sols de verre au logement en haut laissent entrer la lumière du jour jusqu'au rez-de-chaussée et éclairent la zone d'entrée par le toit.

Tostada y oxidada el revestimiento de la fachada de acero Corten perforado recuerda al puerto. Le brinda privacidad a los habitantes y les permite una vista panorámica libre. Los pisos de vidrio en el departamento superior, llevan luz del día hasta la planta baja e iluminan la zona de acceso sobre el techo.

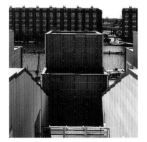

Patio Malaparte

Rudy Uytenhaak Architectenbureau BV, Rudy Uytenhaak,
Engbert van der Zaag
Pieters Bouwtechniek (SE)

2001
Feike de Boerlaan /
Borneokade /
Hofmeesterstraat
Borneo-Sporenburg

The project is based on the master plan for Borneo, in which built-up and open strips join together to a dense carpet of flats. By replacing the open strips by inner courtyards, a building typology is produced which permits a building density of 200 houses per hectare.

Das Projekt basiert auf dem Masterplan für Borneo, bei dem sich bebaute und unbebaute Streifen zu einem dichten Teppich aus Wohnungen zusammenfügen. Indem die unbebaubaren Streifen durch Innenhöfe ersetzt wurden, entstand eine Gebäudetypologie, die eine Bebauungsdichte von 200 Häusern pro Hektar erlaubt.

Le projet se base sur le plan principal de Borneo, qui prévoit de réunir les zones bâties et les zones vagues pour former un tapis dense de logements. En remplaçant les zones vagues par des cours intérieures, une typologie de bâtiment est née, permettant une densité de construction de 200 maisons par hectare.

El proyecto está basado en el plan maestro para Borneo, en el que franjas edificadas y sin edificar se unen en un compacto conjunto habitacional. Al reemplazar las franjas no edificadas por patios interiores, se produjo una tipología de edificación que permite una densidad de construcción de 200 casas por hectárea.

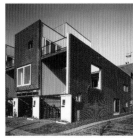

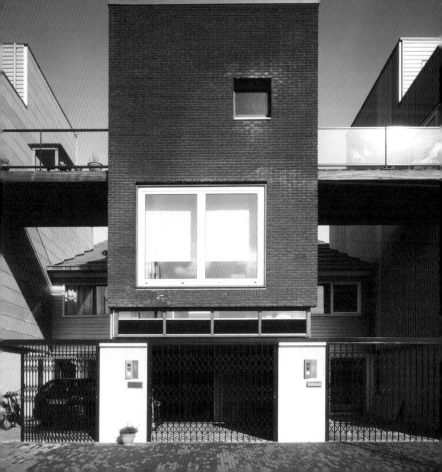

KNSM- and Java Eiland

Diener & Diener Architekten
Ingenieursgroep van Rossum BV (SE)

2001
Bogortuin 109
Borneo-Sporenburg

As a striking finish to the row of super-blocks (designed by the architects Albert and Kollhoff), the buildings appear to set up a link to the neighboring island and put the whole area in perspective to the town. Their arrangement and typology create an internal correlation with the neighboring docklands.

Als markanter Abschluss in der Reihe der Superblocks (Architekten Albert und Kollhoff) entwickeln die Gebäude eine Verbindung zur benachbarten Insel und setzen das ganze Gebiet in eine Beziehung zur Stadt. Ihre Anordnung und Typologie schafft einen inneren Zusammenhang mit den benachbarten Hafenbauten.

Comme fin marquante de la rangée de super-blocs (architectes : Albert et Kollhoff), les bâtiments semblent établir une liaison avec l'île voisine et relient l'ensemble de la zone à la ville. Leur disposition et typologie créent un rapport interne avec les constructions portuaires voisines.

Como terminación relevante en la serie de los superbloques (arquitectos Albert y Kollhoff) los edificios desarrollaron un enlace con la vecina isla y relacionan toda la región con la ciudad. Su disposición y tipología crean una relación interna con los edificios portuarios vecinos.

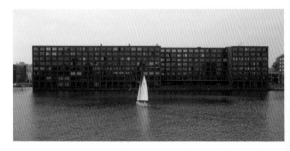

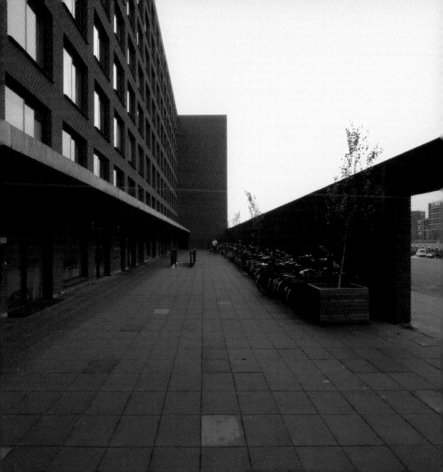

Waterdwellings

Tangram Architekten
SBDN (SE)

1999
Schillingdijk
Osdorp

www.tangramarchitekten.nl

The motifs for this project are the conservation of natural living spaces as well as the consideration of the ecological aspects in material choice and utilization of resources. The buildings are developed from the bases in the water. Wooden connecting platforms take the place of expensive real estates.

Natürliche Lebensräume zu erhalten sowie ökologische Aspekte in Materialwahl und Ressourcennutzung zu berücksichtigen sind die Motive für dieses Projekt. Die Gebäude werden über die Sockel vom Wasser aus erschlossen. Hölzerne Verbindungsplattformen ersetzen teure Grundstücke.

L'objectif de ce projet est de respecter les espaces vitaux naturels et les aspects écologiques dans le choix des matériaux et l'utilisation des ressources. Les bâtiments sont ouverts depuis leurs fondations dans l'eau. Des plates-formes de liaison en bois remplacent des biens-fonds coûteux.

La conservación de espacios vitales naturales, como también la consideración de los aspectos ecológicos de la elección de materiales y recursos, fueron los motivos para este proyecto. Los edificios se urbanizan sobre pilares desde el agua. Plataformas de unión hechas de madera reemplazan terrenos caros.

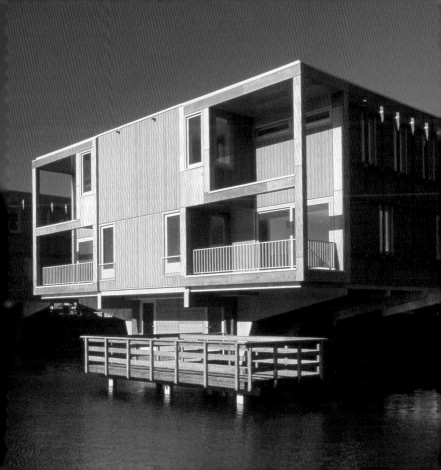

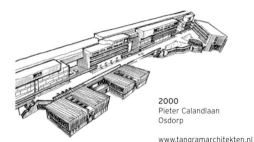

Dukaat

Tangram Architekten
ING Vastgoed (SE)

2000
Pieter Calandlaan
Osdorp

www.tangramarchitekten.nl

Towards the street area, the residential building of 400 meters (440 yds.) in length presents a circulating shopping zone with a supply area on the inside. Moreover, there is an elementary school, a kindergarten as well as recreation centers for the residents. Breakthroughs create a cross connection between the square and the street.

Zum Straßenraum präsentiert das 400 Meter lange Wohngebäude eine umlaufende Einkaufszone mit innen liegendem Zulieferbereich. Den Bewohnern stehen außerdem eine Grundschule, ein Kindergarten sowie Freizeitzentren zur Verfügung. Durchbrüche schaffen Querverbindungen zwischen Platz und Straße.

Orientés vers la voie publique, le bâtiment d'habitation de 400 m de long présente une zone commerciale circulaire avec une aire de livraison intérieure. En outre, les habitants disposent d'une école primaire, d'une école maternelle et de centres de loisirs. Des percées rejoignent la place et la rue.

Hacia la calle exterior pública el edificio habitacional de 400 metros de largo está rodeado de una zona comercial con una zona interior de accesos de abastecimiento. Los habitantes además cuentan con un colegio básico, una guardería ínfantil, como también con centros de actividades de recreo. Aberturas crean conexiones transversales entre plaza y calle.

Hoytema Residence

Heren 5 architecten

2003
Th. Van Hoytemastraat /
Derkinderenstraat
Overtoomse Veld

www.heren5.nl

The residential complex adopts the advantages of the neutral building style of the surroundings, but at the same time it stands out in shape and material as well as by the arrangement around a central garden area, which creates an individual atmosphere in the middle of the monotonous grid of the garden city.

Der Wohnkomplex macht sich die Vorteile der neutralen Gebäuderiegel der Umgebung zu Eigen, hebt sich aber gleichzeitig ab in Form und Material sowie durch die Anordnung um einen zentralen Gartenbereich. Dieser schafft eine individuelle Atmosphäre inmitten des eintönigen Rasters der Gartenstadt.

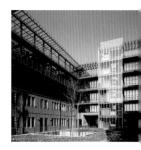

Le complexe d'habitation adopte les avantages du style de construction neutre des environs, mais s'en distingue également tant par sa forme et ses matériaux que par sa disposition autour d'un jardin central, qui crée une atmosphère individuelle au milieu du schéma uniforme de la cité-jardin.

El complejo habitacional utiliza las ventajas de neutralidad de las edificaciones en el entorno y, sin embargo, se destaca en cuanto a forma y materiales, como también por su disposición alrededor de un jardín central. Éste crea una atmósfera individual en medio del cuadro monótono de la ciudad jardín.

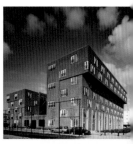

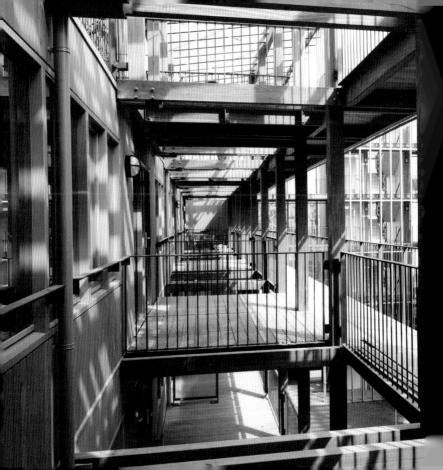

Timorplein / Borneodriehoek

Herman Zeinstra, Atelier Zeinstra van der Pol BV
Strackee (SE)

2004
Timorplein /
Borneostraat /
Delistraat
Zeeburgereiland

www.zeinstravanderpol.nl
www.zeintravanderpol.nl

The four-part complex contains flats, studios, penthouses, maisonettes and council flats as well as flats adapted to the needs of the disabled in spacious buildings with open galleries and room-high windows. The facades made of red-brick elements, glass and steel are uniformly rhythmed.

Der vierteilige Komplex umfasst Apartments, Studios, Penthouse-, Maisonette- und Sozialwohnungen ebenso wie behindertengerechte Wohnungen in großzügigen Gebäuden mit offenen Galerien und raumhohen Fenstern. Die Fassaden aus Backsteinelementen, Glas und Stahl sind einheitlich rhythmisiert.

Le complexe en quatre parties comprend des appartements, des studios, des penthouses, des maisonnettes et des logements sociaux, ainsi que des logements pour personnes à mobilité réduite, situés dans des bâtiments spacieux avec des galeries ouvertes et de hautes fenêtres jusqu'au plafond. Les façades en briques rouges, verre et acier sont uniformément rythmées.

El complejo de cuatro partes comprende departamentos, estudios, penthouses, maisonettes y viviendas sociales, como también departamentos adaptados a minusválidos, en edificios de alto vuelo con galerías abiertas y ventanas de piso a cielo. Las fachadas hechas con elementos de ladrillo, vidrio y acero, tienen un ritmo unitario.

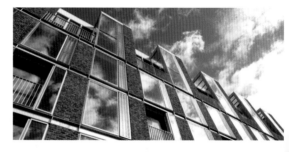

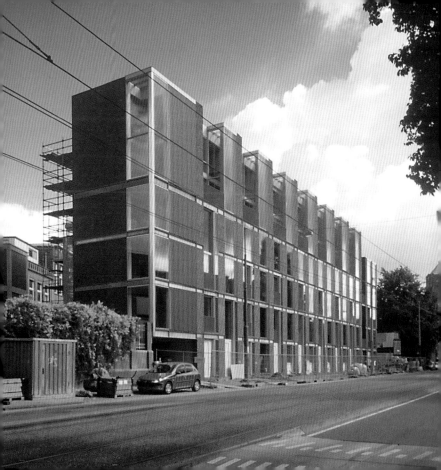

Watervillas Almere

UN Studio
Ingenieursgroep van Rossum BV (SE)

2001
Eilandenbuurt
Almere-Buiten

www.unstudio.com

Every owner can set up his house individually from a modular system. The basic module consists of two in a shifted way staggered concrete parts, thus automatically producing a balcony. Additional modules made of steel are suspended or placed randomly and are used as a winter garden, balcony or additional room.

Aus einem Modulsystem kann sich jeder sein individuelles Haus zusammenstellen. Das Grundmodul besteht aus zwei versetzt gestapelten Betonteilen. Dadurch entsteht automatisch ein Balkon. Zusatzmodule aus Stahl werden beliebig angehängt oder aufgesetzt und dienen als Wintergarten, Balkon oder Zusatzraum.

Chacun peut composer sa maison individuellement à partir d'un système modulaire. Le module de base se compose de deux parties décalées en béton, qui forment automatiquement un balcon. Des modules complémentaires en acier sont suspendus ou posés au hasard et servent de jardin d'hiver, de balcon ou de pièce supplémentaire.

De un sistema de módulos cada uno puede formar su casa individual. El modelo básico se compone de dos partes de hormigón montadas en forma desplazada. De ese modo automáticamente se forma un balcón. Se pueden agregar módulos adicionales de acero a voluntad y sirven como jardín de invierno, balcón o pieza adicional.

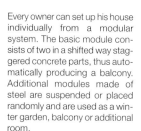

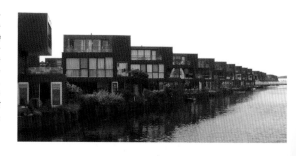

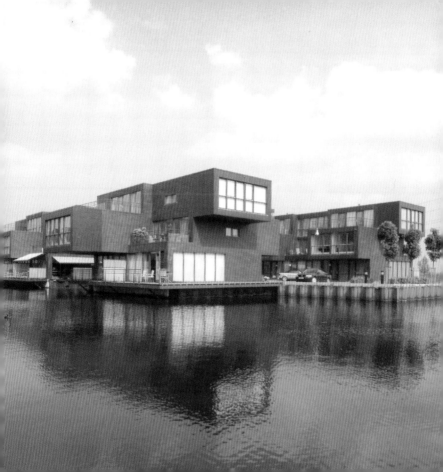

Loftice

Bastiaan Jongerius
ABT Delft (SE)

2002
de Ruijterkade 112
Center

www.bjarchitecten.demon.nl

By its external shape, the building is to produce a symbolic link across the railway track joining the old town and the river. The inside two-part organization is reminiscent of the neo-classical canal house. When viewed from a traveling train, the building seems to change its color from silver to dark blue.

Durch seine äußere Form soll das Gebäude symbolisch die Verbindung zwischen Altstadt und Fluss über die Bahntrasse hinweg herstellen. Die innere, zweigeteilte Organisation verweist auf das neoklassizistische Kanalhaus. Vom fahrenden Zug aus betrachtet scheint das Gebäude seine Farbe von Silber in Dunkelblau zu ändern.

Par sa forme extérieure, le bâtiment doit créer une liaison symbolique entre la vieille ville et la rivière par-dessus la ligne ferroviaire. La disposition intérieure en deux parties fait référence à la maison de type néoclassique le long des canaux. Depuis un train en marche, le bâtiment semble changer de couleur, de l'argenté au bleu foncé.

Mediante de su forma exterior, el edificio quiere simbolizar la conexión entre el casco antiguo de la ciudad y el río, más allá hacia el trazado ferroviario. La organización interior bipartita recuerda la casa de canal del neoclasicismo. Visto desde el tren en marcha, el edificio parece cambiar su color del plateado al azul oscuro.

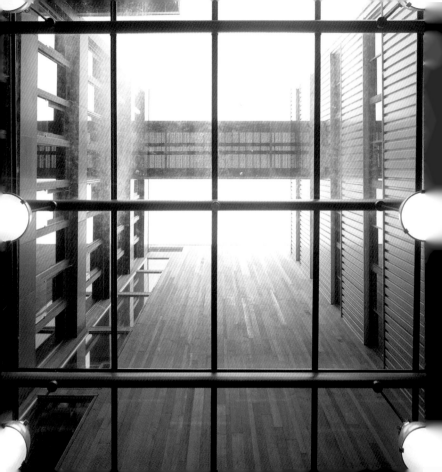

Pakhuis Amsterdam

Conversion Warehouse

Meyer en van Schooten Architecten
ABT Arnhem (SE)

1999
Oostelijke Handelskade 17
Stadsried-Landen

A former warehouse was transformed into a showroom for designers. The industrial character of the building was retained as far as possible. Supplementary components contrast by their materials. Glass staircases cross through several storeys of airy rooms, permitting eye contacts between the exhibition levels.

Aus einem früheren Lagerhaus entstand ein Showroom für Designer. Der industrielle Charakter des Gebäudes wurde weitgehend belassen. Ergänzende Bauteile kontrastieren in den Materialien. Glastreppen durchkreuzen mehrgeschossige Lufträume, die Blickkontakte zwischen den Ausstellungsebenen zulassen.

Une salle d'exposition pour designers a été créée dans un ancien entrepôt. Le caractère industriel du bâtiment a été largement conservé. Les autres éléments contrastent par leurs matériaux. Des cages d'escalier de verre traversent plusieurs étages d'espaces ouverts, permettant un contact visuel entre les niveaux d'exposition.

Un almacén de antaño se convirtió en una sala de exposiciones para diseñadores. Se mantuvo el carácter industrial del edificio. Elementos de construcción complementarios contrastan en sus materiales. Escaleras de vidrio atraviesan espacios libres de varios pisos, lo que permite el contacto visual entre los diferentes niveles de exposición.

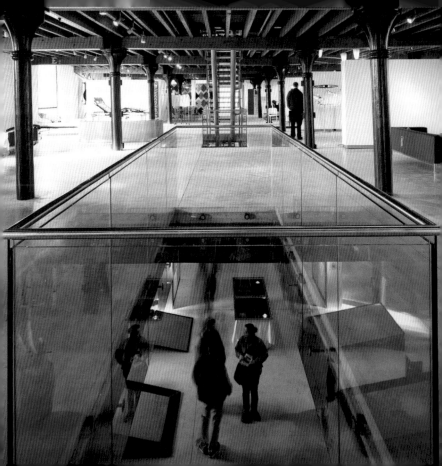

Eurotwin Business Center

Claus en Kaan Architecten

1995
Papaverweg
Amsterdam Noord

www.clausenkaan.nl

The settlement of young companies as producers of momentum requires competitively-priced premises. Industry is put up in a flat structure with connection to the street, whereas the offices are removed from street noise by their vertical arrangement. The oiled wooden facade looks like concrete.

Die Ansiedlung junger Unternehmen als Impulsgeber verlangt nach preiswerten Räumlichkeiten. Die Industrie ist mit Verbindung zur Straße in einem flachen Baukörper untergebracht, während sich die Büros durch vertikale Anordnung dem Straßenlärm entziehen. Wie Beton wirkt die geölte Holzfassade.

L'établissement de jeunes entreprises comme créateurs d'impulsion nécessite des locaux à prix avantageux. L'industrie est installée dans une construction basse reliée à la rue, tandis que les bureaux sont écartés du bruit de la rue par une disposition verticale. La façade en bois huilé ressemble au béton.

El establecimiento de empresarios jóvenes como impulsores exige localidades económicas. La industria está instalada en una edificación plana que da hacia la calle, mientras que las oficinas construídas en forma vertical escapan al ruido callejero. La fachada de madera aceitada da la impresión de ser de hormigón.

Ogilvy Group Nederland bv

Witteveen Visch Architecten

2002
Pilotenstraat 41
Oud-Zuid

www.witteveenvisch.nl

The office area in a former factory located in the "De Schinkel" area is as large as a soccer field. The spatial partitions and the individual offices are hardly noticeable below the high sheds of the roof. The gigantic room of 115 x 50 meters (126.5 x 55 yds.) is interrupted by four large inner courtyards only.

So groß wie ein Fußballfeld ist der Raum für eine Bürofläche in einer ehemaligen Fabrik im De Schinkel Arial. Unter den hohen Sheds des Daches sind räumliche Teilungen und Einzelbüros kaum wahrnehmbar. Der riesige, 115 x 50 Meter große Raum wird nur von vier großen Innenhöfen unterbrochen.

L'espace réservé aux bureaux dans une ancienne usine située dans l'aire « De Schinkel » est aussi grand qu'un terrain de football. Les divisions spatiales et bureaux individuels sont à peine perceptibles sous les sheds du toit. Cet immense espace (115 x 50 mètres) n'est découpé que par quatre grandes cours intérieures.

El espacio para oficinas, en una fábrica de antaño en el sector "De Schinkel" es del tamaño de una cancha de fútbol. Bajo las grandes alturas del edificio con el típico techo en forma de dientes de sierra prácticamente pasan desapercibidas las divisiones del interior y las oficinas individuales. El inmenso espacio de 115 x 50 metros, sólo es interrumpido por cuatro grandes patios interiores.

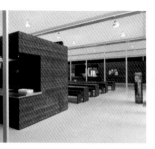

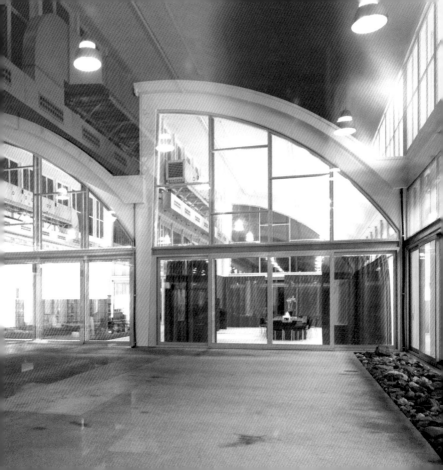

Apollo Building

Skidmore Owings & Merrill Inc
Ingenieursgroep van Rossum BV (SE)

1998
Apollo Laan 150
De Pijp

www.som.com

A slender bow-like shape communicates between the neighboring hotel and the low neighboring houses. Large window surfaces and warm Portuguese limestone dominates the facades of the building which has been designed extremely detailed on the inside rooms as well, and which has been built from high-quality materials.

Eine schlanke, schiffsbugartige Form vermittelt zwischen dem benachbarten Hotel und der niedrigen Nachbarbebauung. Große Fensterflächen und warmer, portugiesischer Kalkstein bestimmen die Fassaden des bis in die Innenräume äußerst genau detaillierten und aus hochwertigen Materialien entwickelten Gebäudes.

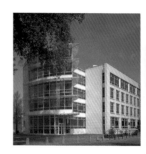

Une forme étroite, semblable à une proue, fait la transition entre l'hôtel voisin et les constructions basses adjacentes. De grandes fenêtres et des pierres calcaires portugaises dominent les façades du bâtiment dont la construction avec des matériaux de qualité est extrêmement détaillée, à l'intérieur également.

Una esbelta forma que recuerda a la proa de un barco hace de intermediario entre el hotel y las bajas edificaciones vecinas. Grandes ventanales y la cálida piedra caliza portuguesa determinan las fachadas del edificio, en cuyo interior detallado al máximo se ha utilizado materiales de alta calidad.

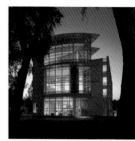

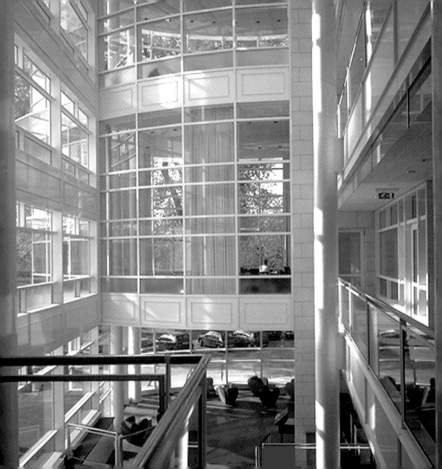

World Trade Center Amsterdam

Kohn Pedersen Fox Associates PA
Ingenieursgroep van Rossum BV (SE)

2002
Strawinskylaan 1
De Pijp

www.wtcamsterdam.com
www.kpf.com

Due to the railway lines and the motorways, the office quarter was isolated from the economic and municipal development for a long time. New entrances, more car parks, better lifts and escalators as well as the modernization of the facades and the extension of the office areas have revitalized the WTC completely.

Durch Schienen und Autobahnen war das Büroviertel lange Zeit von der wirtschaftlichen und städtischen Entwicklung isoliert. Neue Eingänge, mehr Parkplätze, bessere Aufzüge und Rolltreppen sowie die Modernisierung der Fassaden und Erweiterung der Büroflächen haben das WTC umfassend wieder belebt.

En raison des voies ferrées et des autoroutes, le quartier des bureaux a longtemps été isolé du développement économique et de la ville. De nouvelles entrées, davantage de places de stationnement, de meilleurs ascenseurs et escalators, ainsi que la modernisation des façades et l'agrandissement des surfaces de bureaux ont totalement réanimé le WTC.

Debido a vías férreas y autopistas el barrio de oficinas mucho tiempo estuvo aislado del desarrollo comercial y urbano. Nuevos accesos, más aparcamientos, mejores ascensores y escaleras mecánicas, como también la modernización de las fachadas y la ampliación de las superficies destinadas a oficinas, han hecho revivir al WTC.

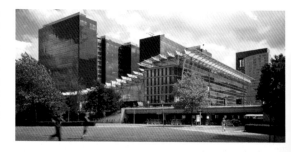

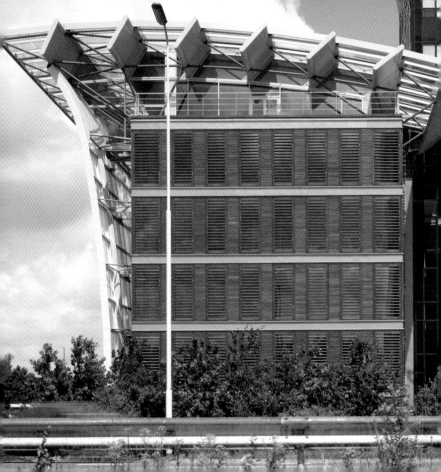

Philips Headquarters

Skidmore Owings & Merrill Inc
SOM (SE)

2001
Amstelplein 2
Amsterdam Oost

www.som.com

The tower of 90 meters (99 yds.) is to radiate transparency. The large glazed office wing clings to the core clad in aluminum. Sections in the volume permit views on to the framework. The topmost stories house a public exhibition area as well as an auditorium and a cafeteria.

Der 90 Meter hohe Turm soll Transparenz ausstrahlen. An den mit Aluminium verkleideten Kern schmiegen sich die großflächig verglasten Büroflügel. Ausschnitte im Volumen geben Blicke auf das Tragwerk frei. Die obersten Etagen beherbergen öffentliche Ausstellungsbereiche sowie ein Auditorium und die Cafeteria.

La tour de 90 mètres de haut doit rayonner de transparence. Les grandes ailes vitrées des bureaux adhèrent au centre recouvert d'aluminium. Des ouvertures dans le volume libèrent la vue sur la structure portante. Les étages supérieurs hébergent des zones d'exposition publiques, ainsi qu'un auditoire et une cafétéria.

La torre de 90 metros de altura debe irradiar transparencia. Al centro revestido con aluminio se apegan las grandes superficies de vidrio de las oficinas. Aberturas en el volumen descubren la estructura portante. Los pisos superiores albergan lugares públicos de exposición, como también un auditorio y una cafetería.

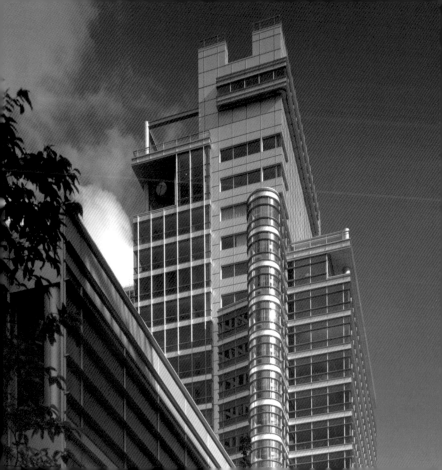

ING Group Headquarters

Meyer en van Schooten Architecten
Aronsohn Raadgevende Ingenieurs BV (SE)

2002
Amstelveenseweg 500
Amsterdam Zuid

Symbol for dynamics, innovation and openness: On the one hand flat and overhanging facing nature, on the other hand tall towards the town—the headquarters of an insurance company rests on pillars over the level of the motorway. The motorists continue to have a view of nature, and the views from the offices are unobstructed.

Symbol für Dynamik, Innovation und Offenheit: Einerseits flach und überhängend der Natur zugewandt, andererseits hoch aufgeschossen zur Stadt hin, erhebt sich der Hauptsitz einer Versicherungsbank auf Stützen über das Autobahnniveau. Der Blick in die Natur bleibt den Autofahrern unverstellt und die Sicht aus den Büros ist frei.

Symbole de dynamisme, d'innovation et d'ouverture : d'une part tourné vers la nature par sa structure basse en saillie, d'autre part dirigé vers la ville par sa forme élancée, le siège d'une compagnie d'assurance repose il s'élève sur piliers au-dessus de l'autoroute. Les automobilistes continuent de voir la nature et la vue des bureaux est dégagée.

Símbolo de dinámica, innovación y transparencia: por un lado plano y sobresaliente hacia la naturaleza, por el otro una construcción alta hacia la ciudad, se levanta la casa central de un banco de seguros en pilotes sobre el nivel de la autopista. Los automovilistas siguen viendo la naturaleza y la vista desde las oficinas está libre.

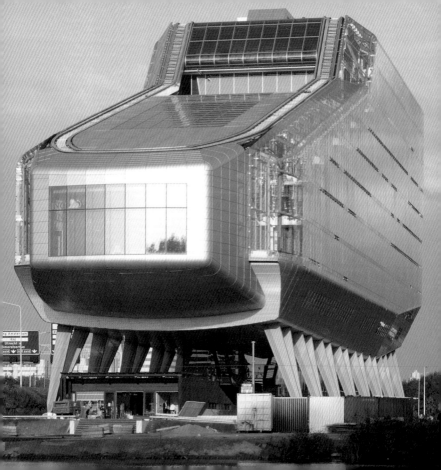

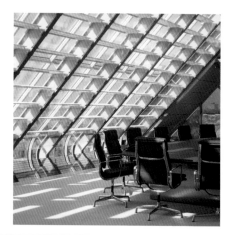

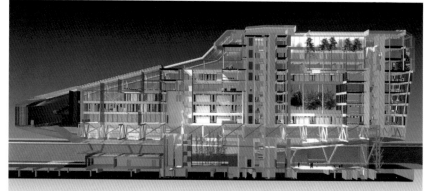

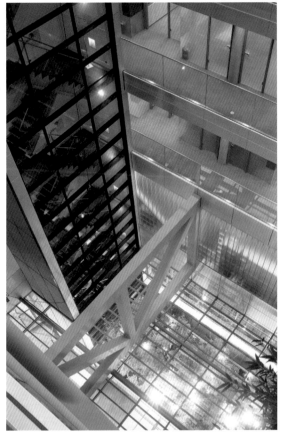

Office Building Oficio

Van den Oever, Zaaijer & Partners architecten
Van der Vorm Engineering Maarssen (SE)

2002
Paasheuvelweg 1
Amsterdam Southeast

www.oz-p.nl

The office building is a widely visible landmark of the adjacent industrial park. The high-tech facade in the front protects against exhaust and noise, and it is used as a climatic buffer. Balconies in front of moveable wooden doors on the inside facade are frequently used by the staff members, giving the building the appearance of liveliness.

Das Büro ist ein weit sichtbares Zeichen für den angrenzenden Gewerbepark. Die vorgelagerte High-Tech-Fassade schützt vor Abgasen und Lärm und dient als Klimapuffer. Balkone vor verschiebbaren Holztüren der inneren Fassade werden von den Mitarbeitern gerne genutzt und verleihen dem Gebäude Lebendigkeit.

Le bureau est un symbole largement visible du parc commercial voisin. La façade high-tech en face protège le bâtiment des gaz d'échappement et du bruit et sert de tampon climatique. Des balcons en face des portes coulissantes en bois de la façade intérieure sont souvent utilisés par les employés et confèrent un dynamisme au bâtiment.

La oficina es un símbolo visible desde el parque industrial adyacente. La fachada antepuesta de alta tecnología proteje contra gases de escape y ruido y sirve como zona climática intermedia. Los balcones delante de las puertas corredizas de madera en la fachada interior, son usados gustosamente por el personal y le dan vida al edificio.

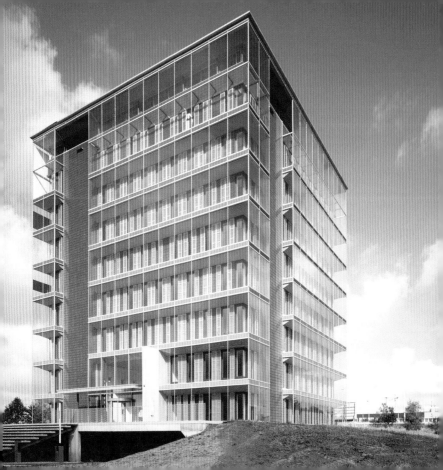

World Trade Center Schiphol

Benthem Crouwel Architekten BV bna
Bureau de Weger (SE)

2003
Airport Schiphol
Schiphol

www.benthemcrouwel.nl

The WTC is part of a complex of offices, conference centers and hotels at Schiphol Airport. A main story with central facilities resting on Y shaped pillars links the eight different parts of the building. Steel, glass, aluminum and granite lend the three-story entrance hall its character.

Das WTC ist Bestandteil eines Komplexes aus Büros, Konferenzzentren und Hotels am Flughafen Schiphol. Ein auf Y-förmigen Stützen ruhendes Hauptgeschoss mit zentralen Einrichtungen verbindet die acht verschiedenen Gebäudeteile. Stahl, Glas, Aluminium und Granit prägen die dreigeschossige Eingangshalle.

Le WTC fait partie d'un complexe de bureaux, de centres de conférence et d'hôtels à l'aéroport de Schiphol. Un étage principal reposant sur des piliers en Y avec des installations centrales relie les huit différents éléments du bâtiment. De l'acier, du verre, de l'aluminium et du granit composent le hall d'entrée à trois étages.

El WTC es parte de un complejo formado por oficinas, centros de conferencia y hoteles en el aeropuerto de Schiphol. Un piso principal con instalaciones centrales que descansa sobre pilares en Y, une las ocho diferentes partes del edificio. Acero, vidrio, aluminio y granito marcan el hall de entrada de tres pisos.

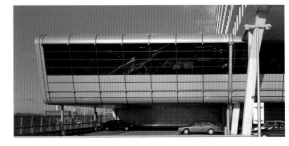

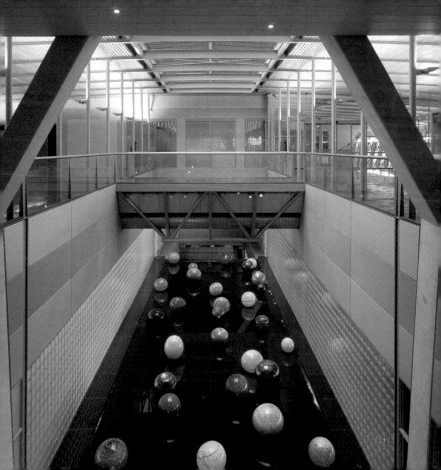

La Defense Almere

UN Studio
JVZ Raadgevend Ingenieursburo (SE)

2004
Willem Dreesweg 14-24
Almere

www.unstudio.com

Urbanity and modesty are to be the reflection of the surroundings in the facade of the building. Multi-color films in the glass panels of the courtyard facade change their color depending on the time of the day. Two interruptions in the closed office complex create a link to the adjacent green space.

Urbanität und Bescheidenheit sollen Reflexionen der Umgebung in der Fassadenhaut des Gebäudes vermitteln. Mehrfarbige Folien in den Glaspaneelen der Hoffassade verändern die Farbe je nach Tageszeit. Zwei Unterbrechungen im geschlossenen Bürokomplex schaffen eine Verbindung zur angrenzenden Grünfläche.

L'urbanité et la simplicité doivent être le reflet des environs dans le revêtement de façade du bâtiment. Des films polychromes placés dans les panneaux vitrés de la façade de la cour changent de couleur selon le moment de la journée. Deux ouvertures dans le complexe de bureaux fermé créent une liaison avec les espaces verts.

Urbanidad y sencillez son reflexiones del entorno que se procuran incorporar a la superficie exterior de la fachada del edificio. Folios multicolor en los paneles de vidrio de la fachada hacia el patio, cambian de color según la hora del día. Dos interrupciones en el complejo de oficinas, crean una conexión con la área verde adyacente.

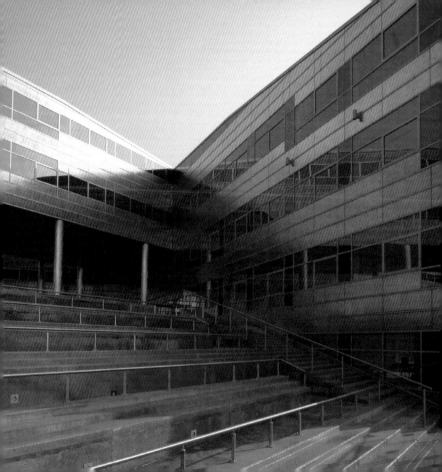

Arcam Architectural Center

René van Architekten BV Zuuk
Eindhoven Van der Laar, Advies en Ingenieursbureau (SE)

2003
Prins Hendrikkade 600
Center

www.arcam.nl
www.renevanzuuk.nl

Located in historic surroundings, the Center for Architecture banks on the sculpture-like effects of its expressive shape. The aluminum facade folds over three stories linked by air spaces on the inside, which completely open with a building-high glass facade towards the main entrance.

In einer historischen Umgebung setzt das Zentrum für Architektur auf die skulpturartige Wirkung seiner ausdrucksstarken Form. Die Aluminiumfassade faltet sich um drei über Lufträume verbundene Geschosse im Innern, die sich zum Haupteingang mit einer gebäudehohen Glasfassade vollständig öffnen.

Situé dans un environnement historique, le centre d'architecture compte sur l'effet sculptural de sa forme expressive. La façade en aluminium se plie sur trois étages intérieurs reliés par des espaces ouverts à l'intérieur, totalement ouverts sur l'entrée principale grâce à une façade vitrée aussi haute comme le bâtiment.

En un entorno histórico, el Centro de Arquitectura se basa en el efecto escultural de su forma altamente expresiva. La fachada de aluminio se pliega alrededor de tres pisos interconectados por espacios libres en el interior, que se abren totalmente hacia la entrada principal con una fachada de vidrio que abarca toda la altura del edificio.

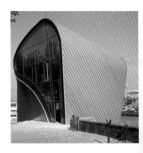

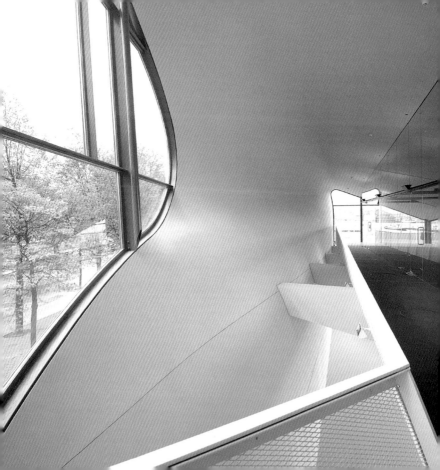

New Metropolis
National Center for Science and Technology

Renzo Piano Building Workshop

1997
Oosterdok 2
Center

www.renzopiano.com

The ship-like building is part of the harbor. It does not stand on land; it floats over a tunnel entrance. The glazed ground floor forms an imaginary water line. A flight of steps on the roof takes the eye back over the town and on the inside a long set of stairs passes down into the catacombs of science.

Das schiffsähnliche Gebäude ist Teil des Hafens. Es steht nicht, es schwimmt über einer Tunneleinfahrt. Das verglaste Erdgeschoss bildet eine imaginäre Wasserlinie. Auf dem Dach lenkt eine Freitreppe den Blick zurück über die Stadt und im Innern führt eine lange Treppe in die Katakomben der Wissenschaft.

Le bâtiment, semblable à un bateau, fait partie du port. Il ne repose pas sur la terre, il flotte au-dessus de l'entrée d'un tunnel. Le rez-de-chaussée vitré forme une ligne d'eau imaginaire. Un perron sur le toit offre une vue sur la ville et, à l'intérieur, un long escalier mène aux catacombes de la science.

El edificio que se asemeja a un buque, forma parte del puerto. No está eregido en tierra, flota sobre una entrada de túnel. La planta baja acristalada forma una línea de agua imaginaria. Sobre el techo una escalinata conduce la mirada hacia la ciudad y en el interior una larga escalera lleva a las catacumbas de la ciencia.

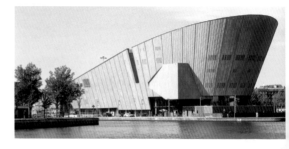

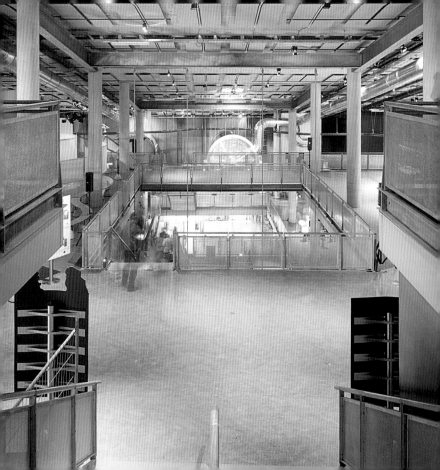

Anne Frank Museum

Benthem Crouwel Architekten BV bna
ABT Delft (SE)

1999
Westermarkt 10
Center

www.annefrank.nl
www.benthemcrouwel.nl

New buildings delicately integrated into the existing town structure with respect to proportion and material supplement Anne Frank's house otherwise restored to its original looks. An atrium secures the distance to the old stock and ensures open transparent inside rooms in the building oriented toward the neighboring church.

In Proportion und Material sensibel in die vorhandene Stadtstruktur eingefügte Neubauten ergänzen das ansonsten originalgetreu restaurierte Anne Frank Haus. Ein Lichthof wahrt die Distanz zum Bestand und sorgt für offene, transparente Innenräume der zur benachbarten Kirche orientierten Gebäude.

Des nouvelles constructions, délicatement intégrées à la structure existante de la ville en respectant les proportions et matériaux, complètent la maison d'Anne Frank autrement restaurée à son apparence d'origine. Un puits de lumière établit la distance avec le bâtiment existant et assure des espaces intérieurs ouverts et transparents dans le bâtiment orienté vers l'église voisine.

Nuevas construcciones se incorporaron sensiblemente a la estructura urbana existente, de modo que las proporciones y materiales se complementen con la casa de Ana Frank, restaurada conforme al original. Un patio de luces mantiene la distancia a los edificios existentes proporcionando claridad y transparencia al interior de los edificios orientados hacia la iglesia colindante.

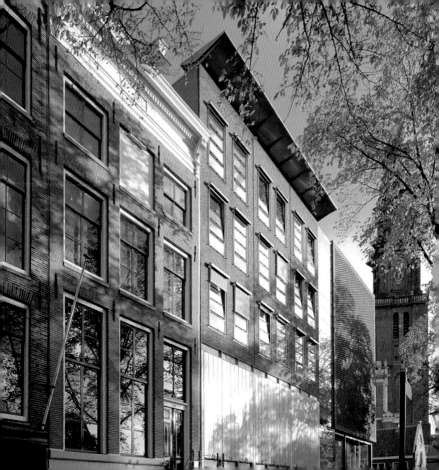

Depot Scheepvaart Museum
Maritime Museum Depot

Liesbeth van der Pol, Atelier Zeinstra van der Pol BV
Government Buildings Department (SE)

2001
Kattenburgerstraat 7
Center

www.zeinstravanderpol.nl

A mysterious content is assumed behind the bent sides and striking pile-ups. In fact, however, the shape of the hermetically closed titanium shell is derived from the inside. Installations are grouped around a concrete box which stores museum pieces at a constant temperature and humidity.

Geknickte Seiten und markante Auftürmungen lassen einen mysteriösen Inhalt vermuten. Tatsächlich leitet sich die Form der hermetisch geschlossenen Titanhülle aus dem Inneren ab. Installationen gruppieren sich um eine Betonbox, die bei konstanter Temperatur und Luftfeuchtigkeit Museumsstücke aufbewahrt.

Des côtés courbés et des piles impressionnantes laissent présager un contenu mystérieux. En fait, la forme de l'enveloppe en titane fermée hermétiquement dérive de l'intérieur. Des installations sont groupées autour d'un coffrage en béton qui conserve les pièces de musée à une température et une humidité atmosphérique constantes.

Paredes laterales dobladas y elevaciones destacadas suponen un contenido misterioso. Efectivamente la forma del envoltorio hermético de titanio surge desde el interior. Alrededor de la caja de hormigón se agrupan instalaciones que, bajo temperatura y humedad constante guardan piezas de museo.

Extension
Bredero College School

De Arichtektengroep
J.P. van Eesteren BV (SE)

2000
Meeuwenlaan
Amsterdam Noord

www.architectengroep.com

The roof as an entrance area and action platform replaces monumental urban development. Oriented toward the street, the kitchen, sports hall and restaurant are showrooms for modern action paedagogics. Sports and game areas on the roof are important supplements to the urban structure characterized by allotments.

Das Dach als Eingangsplatz und Aktionsplattform ersetzt monumentalen Städtebau. Zur Straße hin fungieren Küche, Sporthalle und Restaurant als Showrooms für moderne Aktionspädagogik. Sport- und Spielflächen auf dem Dach bilden eine wichtige Ergänzung im von Kleingärten geprägten städtischen Kontext.

Le toit utilisé comme zone d'entrée et plate-forme d'action remplace l'urbanisme monumental. Orientés vers la rue, la cuisine, la salle de sport et le restaurant servent de salles d'exposition pour une pédagogie d'action moderne. Des aires de sport et de jeu sur le toit sont un complément important à la structure urbaine caractérisée par des lotissements.

El techo como lugar de acceso y plataforma de acción, reemplaza la arquitectura urbana monumental. Cocina, gimnasio y restaurant dan hacia la calle y actúan como salas de exhibición para la pedagogía de acción moderna. Canchas de deporte y juego sobre el techo constituyen un suplemento importante al contexto urbano caracterizado por jardines pequeños.

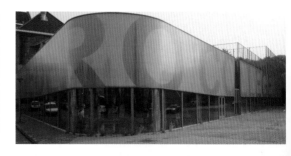

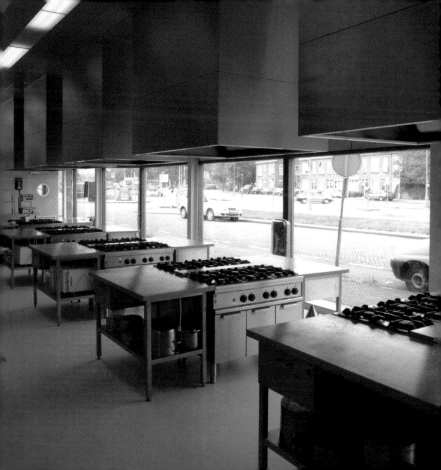

Primary School Horizon

Tangram Architekten
Council of Amsterdam-Osdorp (SE)

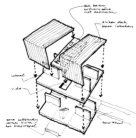

2000
Pieter Calandlaan 768
Osdorp

www.tangramarchitekten.nl

The school is part of a block of flats. The main entrance leads into an inner courtyard. Two building parts on either side house twelve classrooms each on two stories. Spacious corridors are located in the center, which are connected to each other by air spaces and which are used for joint lessons.

Die Schule ist Teil eines Wohnblocks. Der Haupteingang führt zu einem inneren Hof. Zwei flankierende Gebäudeteile beherbergen jeweils in zwei Geschossen zwölf Klassen. In deren Mitte befinden sich großzügige Flure, die über Lufträume miteinander verbunden sind und zum gemeinsamen Unterricht benutzt werden.

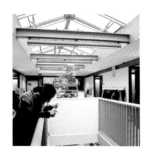

L'école fait partie d'un bloc d'habitation. L'entrée principale conduit à une cour intérieure. Deux éléments du bâtiment connexes abritent chacun douze classes sur deux étages. Des couloirs spacieux situés au centre sont reliés par des espaces ouverts et utilisés pour les cours communs.

El colegio es parte de un bloque habitacional. La entrada principal lleva hacia un patio interior. Cada una de las dos partes laterales del edificio albergan en dos pisos doce salas de clase. En su centro existen amplios pasillos, que están unidos por espacios libres y que se utilizan para clases colectivas.

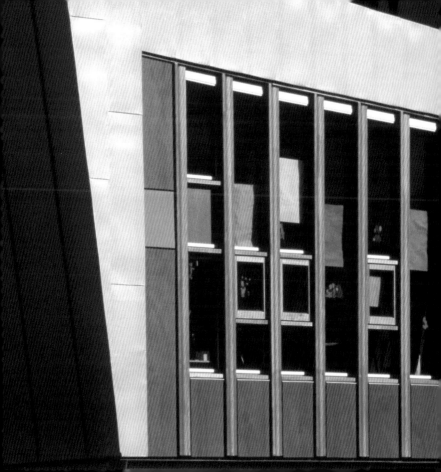

Nicolaas Maesschool

Meyer en van Schooten Architecten
Ingenieursgroep van Rossum BV (SE)

1999
Nicolaas Maesstraat 124-126
Center

Requirements which are hardly compatible with one another: A building bathed in light with small energy-efficient windows and spacious, but low rooms in order to save costs. These requests are met by the use of light-transmissive panels, which ensure light inside rooms and give depth to the facade.

Schwer zu vereinbarende Forderungen: Ein lichtdurchflutetes Gebäude mit kleinen, energieeffizienten Fenstern und großzügigen, aber niedrigen Räumen, um Kosten zu sparen. Erfüllt werden diese Wünsche durch die Verwendung von lichtdurchlässigen Paneelen, die helle Innenräume gewährleisten und der Fassade Tiefe verleihen.

Des exigences difficilement compatibles : un bâtiment inondé de lumière avec de petites fenêtres à haut rendement énergétique et des espaces spacieux mais peu élevés pour réduire les coûts. Ces conditions sont remplies par l'utilisation de panneaux translucides, qui garantissent des espaces intérieurs lumineux et donnent de la profondeur à la façade.

Exigencias difíciles de cumplir son: un edificio luminoso con ventanas pequeñas que ahorran energía y piezas amplias pero bajas, para reducir costes. Estas demandas se cumplen con la utilización de paneles transparentes, que garantizan claridad de interiores y dan profundidad a la fachada.

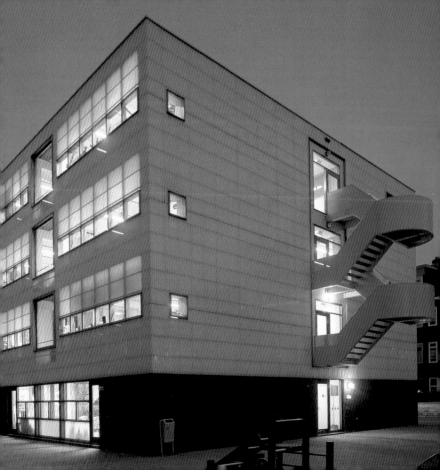

Renovation

Concert Hall

Merkx+Girod architects

1888 (ori. Building) 2006
Concertgebouwplein 2-6
Oud-Zuid

www.concertgebouw.nl
www.merkx-girod.nl

The interior of the world-famous concert hall has been renovated completely. All rooms open to the public were renewed; the capacity was increased, and the flow of traffic and the workshops were optimized whereby the styles of various epochs and the famous acoustics of the hall remained unchanged.

Das Interieur des weltberühmten Konzerthauses wurde umfassend saniert. Alle öffentlichen Räume wurden erneuert, das Fassungsvermögen vergrößert und die Verkehrsströme und Arbeitsstätten optimiert, wobei die Stile verschiedener Zeitepochen und die berühmte Akustik des Saales unbeeinträchtigt blieben.

L'intérieur de la très célèbre salle de concert a été totalement restauré. Tous les espaces publics ont été rénovés, la capacité d'accueil augmentée, le flux de circulation et les lieux de travail optimisés, tout en préservant les styles des différentes époques et la fameuse acoustique de la salle.

El interior de la sala de conciertos de renombre universal fue saneado totalmente. Todos los espacios públicos fueron renovados y se aumentó su capacidad optimizando las vías de circulación y lugares de trabajo y manteniendo los estilos de las diferentes épocas y la afamada acústica de la sala.

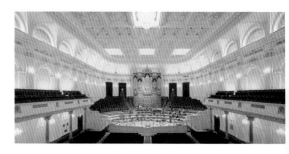

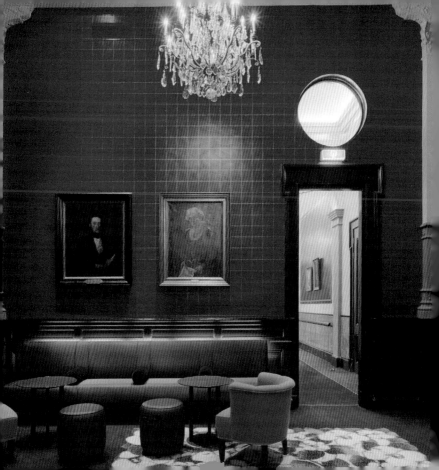

Visitor Center IJburg

Attika Architekten
Ooms Bouwmaatschappij (SE)

2000
IJdijk 50
Zeeburgereiland

www.ijburg.nl
www.attika.nl

The visitor center is a floating temporary building designed for fifteen years. IJburg, the part of town under construction, is to be presented to visitors and potential buyers. Like a village in the water, parts of the building are grouped around a central square. A lookout tower renders an overview of the new townscape.

Das Besucherzentrum ist ein schwimmender Temporärbau für 15 Jahre. Den Besuchern und potenziellen Käufern soll der neu entstehende Stadtteil IJburg vorgestellt werden. Wie ein Dorf im Wasser sind Gebäudeteile um einen zentralen Platz gruppiert. Ein Aussichtsturm verschafft den Überblick im neuen Stadtgebiet.

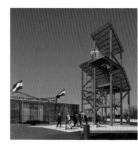

Le centre d'information est un bâtiment flottant provisoire, construit pour une durée de 15 ans. IJburg, le nouveau quartier, doit être présenté aux visiteurs et acheteurs potentiels. Comme un village sur l'eau, les éléments du bâtiment sont groupés autour d'une place centrale. Une tour panoramique offre une vue d'ensemble du nouveau territoire de la ville.

El centro de visitas es una edificación flotante temporal por 15 años. Se desea presentar ante visitantes y compradores potenciales la comuna de IJburg en construcción. Como un pueblo en el agua se agrupan edificios alrededor de una plaza central. Un mirador proporciona una vista panorámica del nuevo barrio.

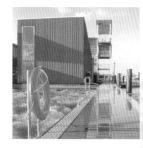

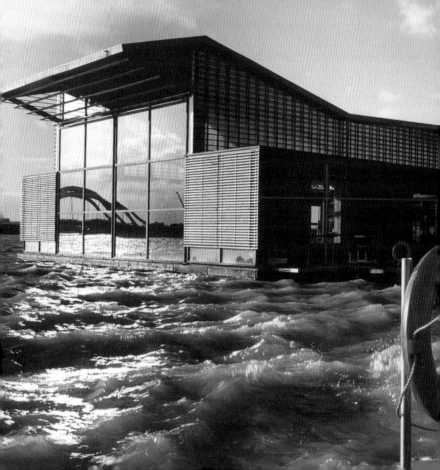

Emma Church

Dumoffice
DRK (SE)

1998
Hugo de Vrieslaan 2
Watergraafsmeer, Noord-Holland

www.kerkdebron.org
www.dumoffice.com

The furniture made of reinforced polyester in a histrionic brownish black appear as if taken from a cartoon. In front of a glass wall which has been designed by the artist Jan Beutener, the liturgy is staged playfully. The spectators sit on comfortable wooden chairs which can also be seen in "Stedelijk Museum".

Wie im Comic wirken die Möbel aus verstärktem Polyester in theatralischem Schwarzbraun. Vor einer Glaswand, die von dem Künstler Jan Beutener gestaltet wurde, setzen sie die Liturgie spielerisch in Szene. Die Besucher sitzen auf bequemen Holzstühlen, wie sie auch im Stedelijk Museum zu betrachten sind.

Les meubles en polyester renforcé d'un brun foncé théâtral semblent sortir d'une bande dessinée. La liturgie est mise en scène de manière ludique devant une paroi vitrée, réalisée par l'artiste Jan Beutener. Les visiteurs prennent place dans des sièges de bois confortables, semblables à ceux du musée « Stedelijk ».

Los muebles de poliéster reforzado de color teatral pardo oscuro, parecen pertenecer a una tira de dibujos animados. Ante una pared de vidrio, creada por el artista Jan Beutener, llevan a escena la liturgia de forma frívola. Las visitas se sientan sobre cómodas sillas de madera, como las que se ven en el Museo Stedelijk.

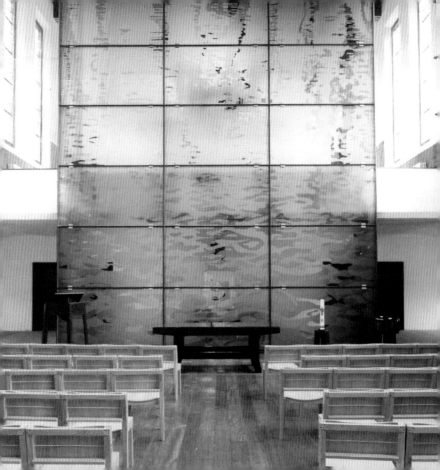

Living Tomorrow Pavilion

UN Studio
Executive Architects Living Tomorrow (SE)

2004
De Entree 300
Amsterdam Zuidoost

www.unstudio.com

The pavilion is to present to the visitors the living concepts and technologies of the future. The curved shape is derived from the parity of verticality and horizontality in the building. The inner organization seeks a presentation of the various exhibitions as uniformly as possible.

Wohnkonzepte und Technologien der Zukunft soll der Pavillon den Besuchern nahe bringen. Die geschwungene Form leitet sich aus der Gleichstellung von Vertikalität und Horizontalität im Gebäude ab. Die innere Organisation strebt eine möglichst einheitliche Darstellung der verschiedenen Ausstellungen an.

Le pavillon doit faire découvrir aux visiteurs les concepts d'habitation et les technologies du futur. La forme courbe s'écarte de l'équilibre entre verticalité et horizontalité du bâtiment. La disposition intérieure recherche une représentation la plus uniforme possible des différentes expositions.

El pabellón desea acercar los visitantes a los conceptos habitacionales y tecnologías del futuro. La forma arqueada se deriva de la igualdad de verticalidad y horizontalidad en el edificio. La organización interior aspira dar una presentación los más homogénea posible a las diferentes exposiciones.

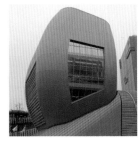

School of Business

ABT Delft (SE)

2003
Fraijlemaborg 133 /
Burg. Stramanweg
Amsterdam Southeast

www.hoogstad.com

The building shrouded in green curved glass presents itself as a town in a town. The complicated structure on the inside houses gardens and exhibition areas in four closed glass rooms. Surprising perspectives and spatial displacements form the environment for intellectual exchanges.

Als Stadt in einer Stadt präsentiert sich das in grünes, geschwungenes Glas gehüllte Gebäude. Die komplizierte Struktur im Innern beherbergt Gärten und Ausstellungsbereiche in vier geschlossenen Glasräumen. Überraschende Perspektiven und räumliche Verschiebungen bilden das Umfeld für geistigen Austausch.

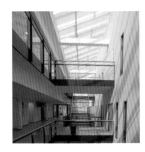

Le bâtiment, dans une enveloppe courbe vitrée de couleur verte, se présente comme une ville dans la ville. La structure intérieure complexe abrite des jardins et des zones d'exposition dans quatre espaces vitrés fermés. Des perspectives surprenantes et des déplacements spacieux forment l'environnement pour des échanges intellectuels.

Como una ciudad dentro de una ciudad, se presenta el edificio cubierto de vidrio curvado verde. La complicada estructura interior alberga jardines y áreas de exposición en cuatro ambientes cerrados de vidrio. Perpectivas asombrosas y desplazamientos de espacios proveen el entorno para un intercambio intelectual.

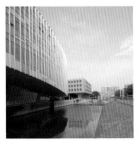

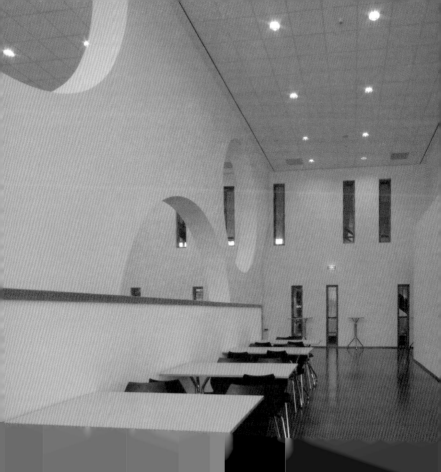

Station Island

Benthem Crouwel Architekten BV bna

1997-2011
Central Station
Center

www.benthemcrouwel.nl

As an attractive nodal point, Amsterdam's central station is to integrate harmoniously into the surroundings. A new underground station with an entrance hall towards the town is under construction underneath the station. Train, bus, underground and water traffic as well as paths for pedestrians and cyclists are linked to one another efficiently.

Als attraktiver Knotenpunkt soll sich der Amsterdamer Hauptbahnhof harmonisch in die Umgebung einfügen. Unter dem Bahnhof entsteht eine neue U-Bahn-Station mit Eingangshalle zur Stadt hin. Zug-, Bus-, U-Bahn- und Wasserverkehr sowie Wege für Fußgänger und Fahrradfahrer werden effizient miteinander verknüpft.

La gare principale d'Amsterdam, en tant que pôle d'attraction, doit s'intégrer harmonieusement dans environs. Une nouvelle station de métro avec un hall d'entrée vers la ville est construite sous la gare. Les trains, les bus, le métro et les voies navigables, ainsi que les trottoirs et les pistes cyclables, sont efficacement reliés.

Como atractivo punto de unión se desea incorporar la estación ferroviaria central de Amsterdam al entorno. Bajo la estación se construye una nueva estación de metro, con hall de entrada hacia la ciudad. Están vinculados eficientemente entre sí el tráfico de trenes, buses, metro y el fluvial, como asimismo los caminos para peatones y ciclistas.

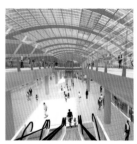

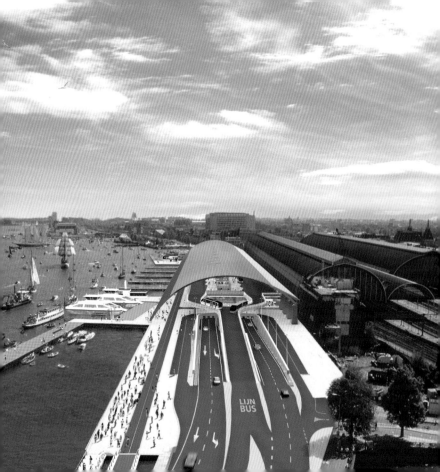

Bicycle Storage

VMX Architects

2001
Stationsplein
Center

www.vmxarchitects.nl

The central station was blocked by masses of parked bicycles in the past. Now they are left in a multi-story bicycle park, which can house five thousand bicycles on ramps. The ramps are made of red asphalt, like the surfaces of Amsterdam's cycleways. Three entrances and numerous cross-links control the traffic.

Massen an parkenden Fahrrädern verstellten früher den Hauptbahnhof. Sie sind jetzt in einem Parkhaus untergebracht. 5000 Fahrräder finden Platz auf Rampen, deren Belag wie bei den Amsterdamer Radwegen aus rotem Asphalt besteht. Drei Eingänge und zahlreiche Querverbindungen regeln den Verkehr.

Avant, des quantités de vélos en stationnement bloquaient la gare principale. Ils sont maintenant garés dans un parking à étages, pouvant contenir 5 000 vélos. Les plates-formes sont recouvertes d'asphalte rouge, comme sur les pistes cyclables d'Amsterdam. Trois entrées et de nombreuses artères transversales contrôlent le trafic.

Una gran cantidad de bicicletas aparcadas obstruían antes la estación central. Ahora están alojadas en un aparcamiento. 5000 bicicletas tienen lugar sobre rampas, que están cubiertas con asfalto rojo, tal como los caminos para ciclistas de Amsterdam. Tres entradas y numerosas comunicaciones transversales regulan el tránsito.

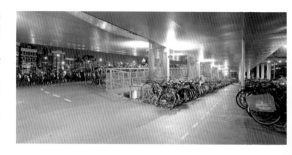

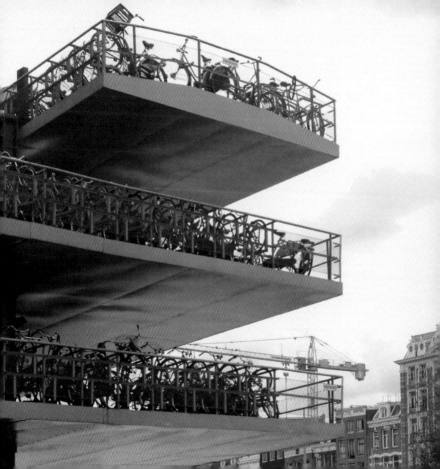

IJburg Bridges

Grimshaw
Ingenieurs Bureau Amsterdam & WS Atkins Oxford (SE)

2001
Pampuslan
Centrumeiland

www.grimshaw-architects.com

The connection to the infrastructure of the town will ensure the success of the IJburg project. The two-story main bridge with a length of 250 meters (275 yds.) from the mainland to the first island is suspended on wave-shaped arches. The construction system will be transferred flexibly to all other bridges.

Die Anbindung an die Infrastruktur der Stadt soll den Erfolg des IJburg-Projektes sicherstellen. An wellenförmigen Bögen spannt sich die zweigeschossige, 250 Meter lange Hauptbrücke vom Festland zur ersten Insel. Das Konstruktionssystem wird flexibel auf alle weiteren Brücken übertragen.

Le raccordement à l'infrastructure de la ville devrait garantir la réussite du projet IJburg. Le pont principal à deux étages d'une longueur de 250 mètres s'étend du continent à la première île, suspendu à des arches en forme de vagues. Le système de construction sera appliqué flexiblement à tous les autres ponts.

La conexión a la infraestructura de la ciudad asegurará el éxito del proyecto IJburg. Arcos ondulantes sostienen el puente principal de dos pisos y 250 metros de largo, que une la tierra firme con la primera isla. El sistema de construcción se transferirá flexiblemente a todos los demás puentes.

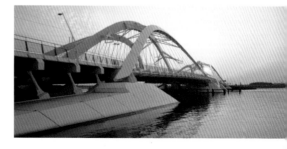

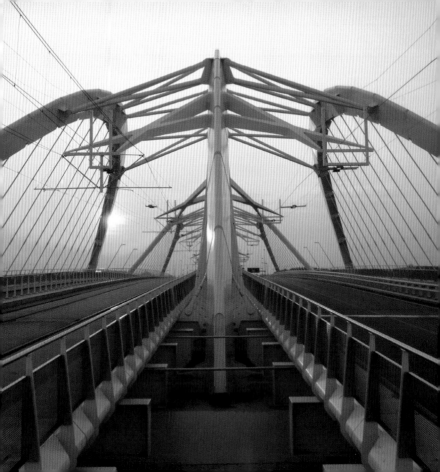

Borneo Sporenburg Bridges

West8 urban design & landscape architecture bv

2000
Stuurmankade /
Panamakade
Borneo-Sporenburg

www.west8.nl

The bridges shape the picture of the harbor neighborhood decisively. Networks of red steel profiles give the two western bridges their sculpture-like effect. Untreated wood covering underlines the industrial character. The third eastern bridge completes the infrastructure of the area.

Die Brücken prägen das Bild der Hafenwohngegend entscheidend. Geflechte aus roten Stahlprofilen verleihen den zwei westlichen Brücken ihre skulpturartige Wirkung. Unbehandelte Holzbeläge unterstreichen den industriellen Charakter. Die dritte, östliche Brücke komplettiert die Infrastruktur des Gebietes.

Les ponts marquent fortement l'apparence du quartier d'habitation du port. Des treillis en profilés d'acier rouges confèrent aux deux ponts occidentaux un effet sculptural. Des revêtements en bois non-traité soulignent le caractère industriel. Le troisième pont à l'est complète l'infrastructure de la zone.

Los puentes caracterizan la imagen de la zona residencial del puerto. Un enjambre de perfiles rojos de acero dan un efecto escultural a los dos puentes occidentales. Revestimientos de madera sin tratar, subrayan el carácter industrial. El tercer puente oriental completa la infraestructura de la región.

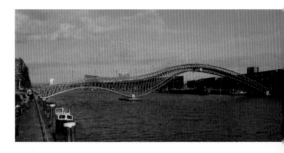

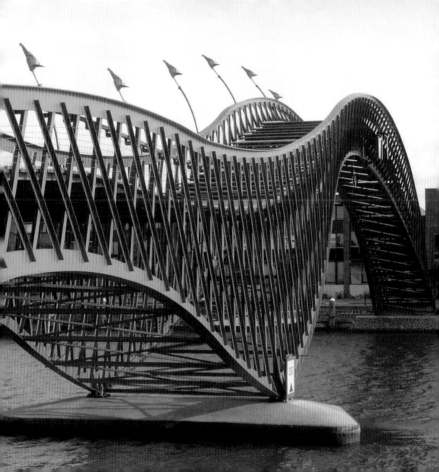

Piet Hein Tunnel

UN Studio
S.A.T Enigeering (SE)

1997
Oosterdok and Zeeburg
Center

www.unstudio.com

Crossed steel constructions above the entrances and two small service buildings dominate the tunnel. A transparent shell surrounds the concrete cores of the building, the characteristic shape of which is derived from the lateral position of the opposite tunnel entrances.

Gekreuzte Stahlkonstruktionen über den Einfahrten und zwei kleine Servicegebäude dominieren den Tunnel. Eine durchsichtige Hülle umgibt die Betonkerne der Gebäude. Deren charakteristische Form leitet sich aus der seitlichen Lage zu den gegenüberliegenden Tunneleingängen ab.

Des constructions en acier croisées au-dessus des entrées et deux petits bâtiments de service dominent le tunnel. Un revêtement transparent entoure le noyau de béton du bâtiment, qui doit sa forme caractéristique à la position latérale des entrées de tunnel opposées.

Estructuras de acero cruzadas sobre las entradas y dos pequeños edificios de servicio, dominan el túnel. Una envoltura transparente rodea los núcleos de hormigón de los edificios, cuya forma caracteristica se deriva de su posición lateral respecto a las entradas de los túneles opuestos.

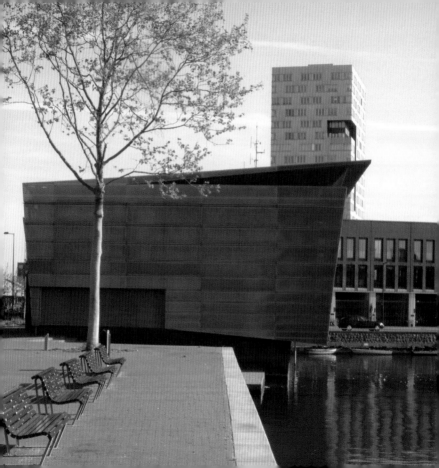

Evenementen Brug

Footbridge

Verburg Hoogendijk Architekten
ABT Delft (SE)

1997
Amsterdam ArenA
Zuidoost

Requirements for high safety, fast handling and short routes led to the concept of the tube. Tie rods and compression bars join the elliptical ribs. As a protection against projectiles, a wire mesh made of stainless steel is laid around the construction which renders the two-dimensional appearance.

Forderungen nach hoher Sicherheit, schneller Abwicklung und kurzen Wegen führten zum Konzept der Röhre. Zug- und Druckstäbe verbinden die elliptischen Rippen. Als Schutz vor Wurfgeschossen legt sich ein Drahtgeflecht aus rostfreiem Stahl um die Konstruktion und verleiht ihr das flächige Erscheinungsbild.

Les exigences de sécurité accrue, d'écoulement plus rapide et de routes directes ont conduit au concept du tube. Les tirants et les barres comprimées relient les nervures elliptiques. En guise de protection contre les projectiles, un treillis métallique en acier inoxydable recouvre la construction, lui conférant une apparence bidimensionnelle.

Las altas exigencias de seguridad, terminación rápida y caminos cortos, llevaron al concepto de tubos. Barras de tracción y compresión unen los nervios elípticos. Como protección contra proyectiles, una malla de acero inoxidable envuelve la construcción y le da el aspecto llano.

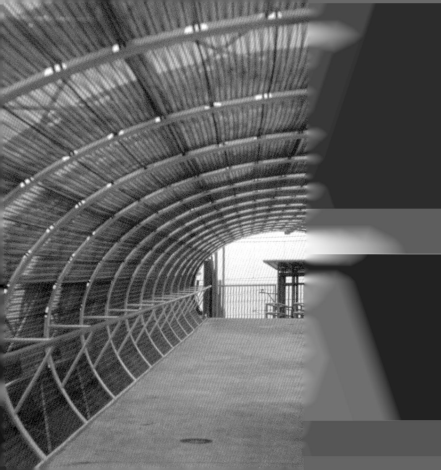

Zorgvlied Cemetery

Claus en Kaan Architecten

1998
Amsteldijk 273
Amsterdam Zuid

www.clausenkaan.nl

The reception pavilion of the Zorgvlied cemetery is located right next to a hall for the last blessing from the 1930ies. The buildings enclose an area, in which the projecting roof of the pavilion enters like a baldachin. Covered with white gravel, the outer and inner area form a unit, separated only by a membrane of glass.

Der Empfangspavillon des Zorgvlied-Friedhofs steht dicht neben einer Aussegnungshalle der 30er Jahre. Die Gebäude umgrenzen einen Raum, in den das Vordach des Pavillons wie ein Baldachin eingreift. Jeweils bedeckt mit weißem Kies bilden Außen- und Innenraum eine Einheit, getrennt nur durch eine Membran aus Glas.

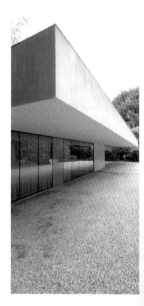

Le pavillon de réception du cimetière de Zorgvlied est situé à proximité d'un funérarium des années 30. Les bâtiments délimitent un espace dans lequel l'avant-toit du pavillon fait saillie, tel un baldaquin. Tous deux recouverts de gravier blanc, les espaces intérieur et extérieur forment une unité que seule une membrane de verre sépare.

El Pabellón de recepción del Cementerio de Zorgvlied se encuentra al lado de una sala para velorios de los años treinta. Los edificios envuelven un recinto, en el que el techo anterior del pabellón se integra como un baldaquín. Estando cubiertos con gravilla blanca, el recinto interior y exterior forman una unidad, separados sólo por una membrana de vidrio.

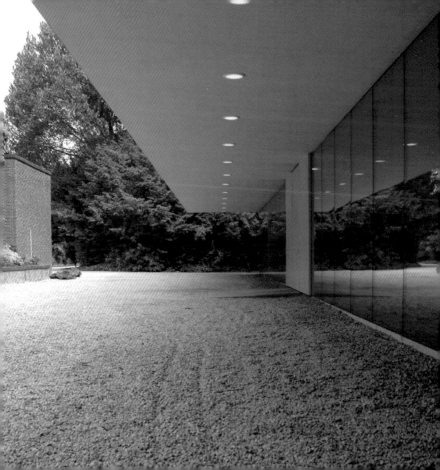

Bus Station Hoofddorp

NIO architecten
Engiplast, Zonneveld Ingenieursbureau (SE)

2003
Voorplein Spaarneziekenhuis
Hoofddorp

www.nio.nl

The eccentric building is made exclusively of polystyrene and polyester. With a length of 50 meters (55 yds.), a width of 10 meters (11 yds) and a height of 5 meters (5.5 yds.), the fully-synthetic construction is considered the largest of its kind worldwide. The unusual curves and bends stimulate individual interpretations.

Das exzentrische Gebäude besteht ausschließlich aus Polysterol und Polyester. Mit 50 Metern Länge, 10 Metern Breite und 5 Metern Höhe gilt die vollsynthetische Konstruktion als die weltweit größte ihrer Art. Die ungewöhnlichen Kurven und Schwünge regen zu individuellen Interpretationen an.

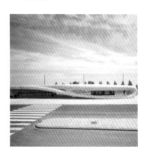

Le bâtiment excentrique se compose exclusivement de polystérol et de polyester. Longue de 50 mètres, large de 10 mètres et haute de 5 mètres, la construction entièrement synthétique est considérée comme la plus grande en son genre au monde. Les courbes et autres inflexions inhabituelles incitent aux interprétations individuelles.

El excéntrico edificio consiste exclusivamente de poliestirol y poliéster. Con un largo de 50 metros, ancho de 10 metros y 5 metros de alto, esta construcción completamente sintética, es la mayor del mundo de su especie. Las extraordinarias briosas y curvas estimulan las interpretaciones individuales.

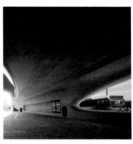

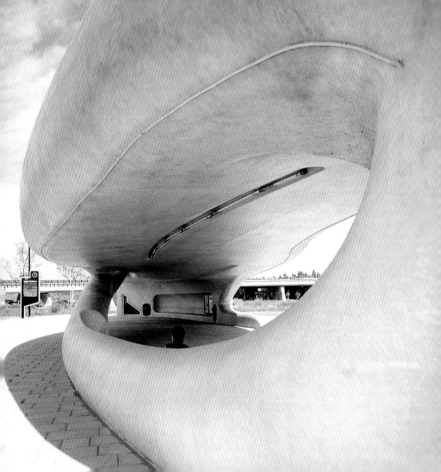

to stay . hotels

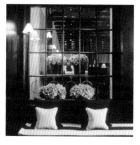
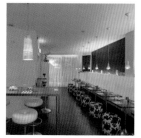

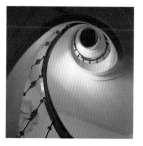
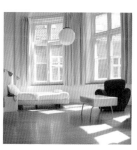
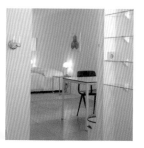
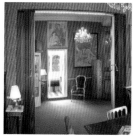
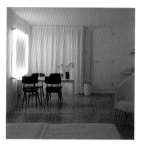

Blakes Hotel

Anouska Hempel

1998
Kreizersgracht 384
Center

www.blakes-amsterdam.com

The visitor is taken back to the heydays of colonial trade with India in this world of spice-colored fabrics and cushions. Black umbrellas in the trellis of lamps in the inner courtyard provide shade. In the over-detailed suites, chocolate ginger and sleeping masks provide sweet escort into the night.

In die Blütezeit des indischen Kolonialhandels versetzt fühlt sich der Besucher in dieser Welt aus gewürzfarbenen Stoffen und Kissen. Im Innenhof spenden im Spalier der Lampen schwarze Schirme Schatten. In detailverliebten Suiten geben Schoko-Ingwer und Schlafmaske süßes Geleit in die dunkle Nacht.

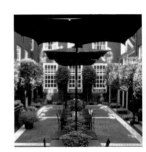

Le visiteur est replongé dans l'époque florissante du monde du commerce colonial indien fait d'étoffes et de coussins aux couleurs épicées. Dans la cour intérieure, des ombrelles noires intégrées au treillis de lampes procurent l'ombre. Dans les suites sur-détaillées, gingembre au chocolat et masque de repos sont d'une douce compagnie nocturne.

El visitante a este mundo de géneros y cojines en color de especias es transportado a la época de apogeo del comercio colonial hindú. En el patio interior, sombrillas negras brindan sombra de lámparas ubicadas en espaldera. En suites repletos de detalles especiales, el chocolate-jengibre y la máscara de dormir invitan a dulces sueños.

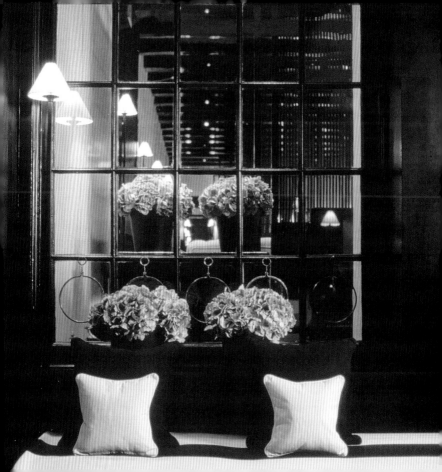

Hotel Seven One Seven

Kees van der Valk

1998
Prinsengracht 717
Center

www.717hotel.nl

The historic facade with its dark-green shutters is an indicator for a high-quality interior already. At the end of a marble hall, an oak staircase leads into the eight suites, which present themselves to the visitors in individual design of old and new.

Die historische Fassade mit ihren dunkelgrünen Fensterläden lässt bereits hochwertiges Interieur erahnen. Am Ende einer Marmorhalle führt eine Eichentreppe in die acht Suiten. In individueller Gestaltung aus Altem und Neuem präsentieren sie sich den Gästen.

La façade historique, avec ses volets vert foncé, témoigne déjà d'un intérieur de grande valeur. A la fin d'un hall en marbre, un escalier en chêne mène aux huit suites qui s'offrent aux hôtes dans un décor singulier fait d'ancien et de moderne.

La fachada histórica con sus postigos verde oscuro, ya permite adivinar su valioso interior. Al final de un hall de mármol una escalera de encina lleva a las ocho suites. Se presentan ante los huéspedes en forma individual con creaciones de lo antiguo y lo nuevo.

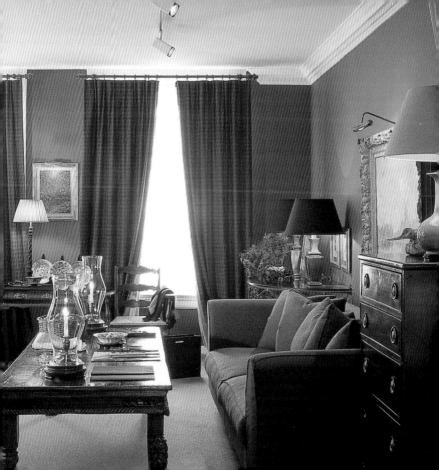

Kien Bed and Breakfast

Mary Kien

1890
2e Weteringdwarsstraat 65
Center

www.marykien.nl

With affection, the owner herself decorated the premises with typical Dutch objects from artists, such as WH Gispen. In the heart of Amsterdam, a wonderfully peaceful atmosphere has been created which stands out for its simplicity.

Von der Besitzerin selbst sind die Räumlichkeiten liebevoll mit typisch holländischen Gegenständen von Künstlern wie WH Gispen ausgestattet. Im Herzen Amsterdams entstand so eine wundervoll friedliche Atmosphäre, die durch ihre Einfachheit besticht.

Les locaux sont décorés avec affection par la propriétaire elle-même à l'aide d'objets typiquement hollandais d'artistes tels que WH Gispen. Dans le cœur d'Amsterdam est ainsi apparue une atmosphère merveilleusement paisible, qui frappe par sa simplicité.

La misma dueña ha alhajado con cariño las habitaciones con objetos típicos holandeses de artistas como WH Gispen. De este modo en el centro de Amsterdam surgió una atmósfera maravillosamente serena, que atrae por su sencillez.

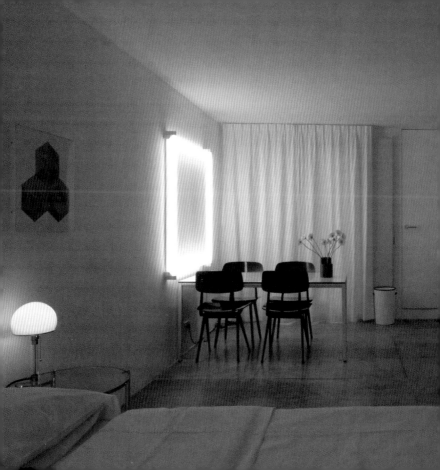

Hotel de Filosoof
Renovation

Colpacci Miclescu architects

1988
Anna van den Vondelstraat 6
Center

www.hotelfilosoof.nl

Proverbially taking philosophy as a solution to everyday problems to the streets is the old tradition of Amsterdam and a matter of concern for the Hotel de Filosoof. The corridors are streets, at the ends of which there are squares, and the rooms are houses of philosophers which all have a fascinating story to tell.

Die Philosophie als Lösung alltäglicher Probleme sprichwörtlich in die Straßen zu tragen, ist alte Tradition Amsterdams und Anliegen des Hotel de Filosoof. Die Flure sind Straßen, an deren Enden sich Plätze befinden, und die Zimmer sind die Häuser der Philosophen, die alle Faszinierendes zu erzählen haben.

Amener proverbialement la philosophie dans la rue comme solution aux problèmes quotidiens est une vieille tradition amstellodamoise et l'objet de l'hôtel de Filosoof. Les couloirs sont des rues qui débouchent sur des places et les chambres, les maisons de philosophes qui ont tous une histoire fascinante à raconter.

Llevar la filosofía a las calles para solucionar los problemas del diario vivir, es una vieja tradición de Amsterdam y objetivo del Hotel de Filosoof. Los pasillos son calles, al final de los cuales hay plazas, y las habitaciones son las casas de los filósofos, que todos cuentan cosas fascinantes.

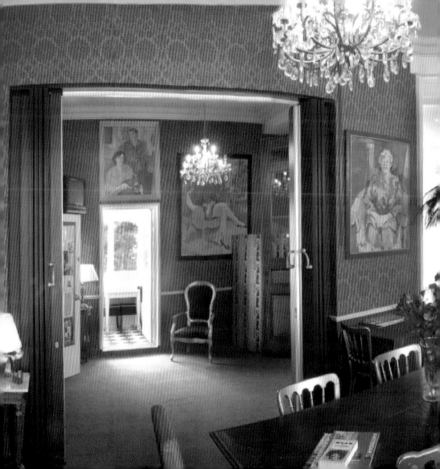

Hotel V

Berlage, Ronald Hoofd, Mirjam Espinosa

1930
Victorieplein 42
De Pijp

www.hotelv.nl

A clear-cut and sober style dominates in the premises of the recently renovated building of the Amsterdam School dating from the beginning of the last century. Garish accessories and furniture in cow design or in rich purple constitute a pleasant contrast to the white walls and the room-high curtains.

In den Räumlichkeiten des kürzlich renovierten Gebäudes der Amsterdamer Schule vom Beginn des letzten Jahrhunderts herrschen klare Linien in nüchternem Stil. Schrille Accessoires und Möbel im Kuhdesign oder in kräftigem Lila bilden einen angenehmen Kontrast zu weißen Wänden und raumhohen Vorhängen.

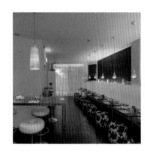

Des lignes claires et un style sobre dominent les locaux du bâtiment récemment rénové de l'école d'Amsterdam du début du siècle dernier. Des accessoires extravagants et des meubles au imprimé vache ou de couleur rose vif constituent un contraste agréable avec les murs blancs et les rideaux jusqu'au plafond.

En los localidades del recién renovado edificio del colegio de Amsterdam que data de comienzos del último siglo, dominan las líneas claras en un estilo sobrio. Accesorios llamativos y muebles en diseño vacuno o de color lila fuerte, contrastan agradablemente con paredes blancas y cortinajes de piso a cielo.

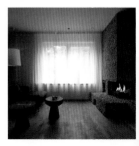

Hotel Arena

IDing, Martin Visser, Studio van Boven, Ronald Hoofd

2004
S'Gravesandestraat 51
Amsterdam Oost

www.hotelarena.nl

For a long time already, the hotel has been considered to be hip and modern. The latest changes in this historic building underline this reputation. The hotel has positioned itself as an important presentation platform for Dutch design and decorates itself with these values: simple, undemanding, versatile and humorous.

Schon lange gilt das Hotel als hip und modern. Die jüngsten Veränderungen in dem historischen Gebäude untermauern diesen Ruf. Das Hotel positioniert sich als wichtige Präsentationsplattform für holländisches Design und schmückt sich mit dessen Werten: einfach, anspruchslos, vielseitig und humorvoll.

L'hôtel est considéré depuis longtemps comme branché et moderne. Les dernières modifications apportées à ce bâtiment historique soulignent cette réputation. L'hôtel se positionne en tant que plate-forme de présentation importante du design hollandais et revêt ces valeurs : simple, sans prétention, varié et plein d'humour.

Hace ya largo tiempo que el hotel es considerado como hip y moderno. Los últimos cambios efectuados en el edificio histórico corroboran esta fama. El hotel es una importante plataforma de presentación del diseño holandés y se adorna con estos valores: sencillo, modesto, versátil y humorístico.

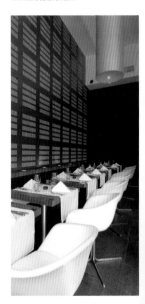

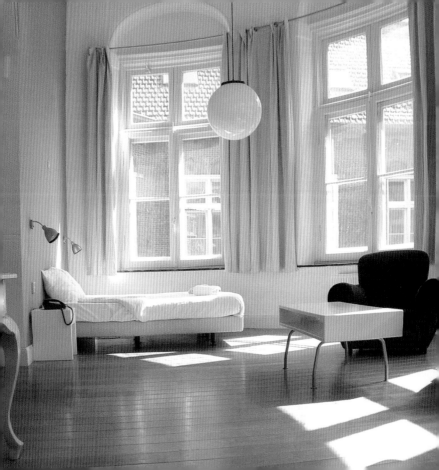

to go . eating
drinking
clubbing
leisure
wellness, beauty & sport

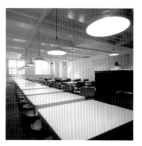
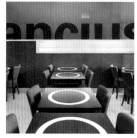

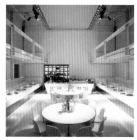
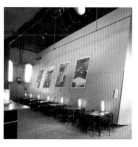
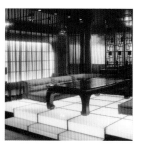

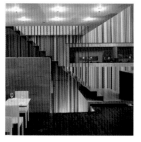

Brasserie Harkema

Herman Prast Architect

2000
Nes 67
Center

www.brasserieharkema.nl

A room situated high up offers a spectacular view along the ceiling into the main hall of the former tobacco factory. Color strips along the wall shine in the bright light of the sheds and contrast with the dark wooden floors and the white furniture in the hall as well as the dark paneled rear wall to the kitchen.

Ein hochgelegener Raum bietet einen spektakulären Blick entlang der Decke in die Haupthalle der ehemaligen Tabakfabrik. Bunte Streifen an der Wand leuchten im hellen Licht der Sheds und kontrastieren mit dunklen Holzböden und weißen Möbeln in der Halle sowie einer dunkel getäfelten Rückwand zur Küche.

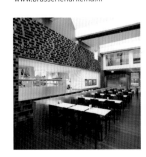

Un espace situé en hauteur offre une vue spectaculaire le long du plafond dans le hall principal de l'ancienne usine de tabac. Des rayures colorées sur le mur resplendissent dans la lumière claire du sheds et contrastent avec les planchers de bois sombres, les meubles blancs du hall et la paroi arrière en lambris sombres vers la cuisine.

Un espacio en lo alto ofrece una vista espectacular a lo largo del techo al hall principal de lo que era antaño una fábrica de tabaco. Rayas multicolores en la pared brillan en la luz del típico techo en forma de dientes de sierra (shed) y contrastan con pisos ocuros y muebles blancos en el hall, como también con el muro posterior hacia la cocina, revestido en madera oscura.

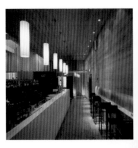

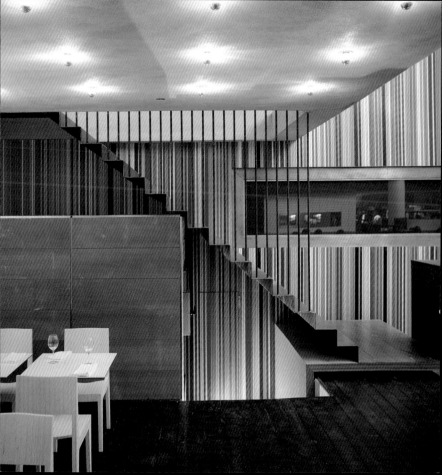

Supperclub Amsterdam

Concrete Architectural Associates

1992
Jonge Roelensteeg 21
Center

www.supperclub.nl
www.concrete.archined.nl

La Salle Neige is completely white. Colored cones of light cross the room. Le Bar Rouge presents itself in the looks of the sixties with red curtains and neon lights. For relaxation, Le Salon Colore has been equipped with a snake-like settee. Black rubber cubes in Les Toilettes Noir invite the guests to stay.

La Salle Neige ist völlig weiß. Farbige Lichtkegel durchkreuzen den Raum. Le Bar Rouge präsentiert sich im Sixties-Look mit roten Vorhängen und Neonlichtern. Zum Relaxen ist Le Salon Colore mit einem schlangenförmigen Sofa ausgestattet. Schwarze Gummiwürfel in Les Toilettes Noir laden zum Verweilen ein.

La Salle Neige est entièrement blanche et traversée de faisceaux lumineux colorés. Le Bar Rouge revêt le look des années 60 avec rideaux rouges et néons. Le Salon Colore, avec ses sofas en forme de serpent, est idéal pour la détente. Des cubes de caoutchouc noir dans Les Toilettes Noir invitent les visiteurs à s'attarder.

La Salle Neige es completamente blanca. Conos luminosos multicolores cruzan el espacio. Le Bar Rouge se presenta con un look de los años sesenta, con cortinas rojas y luces de neón. Para relajarse está Le Salon Colore equipado con un sofá en forma de serpiente. Cubos negros de goma en Les Toilettes Noir invitan a quedarse.

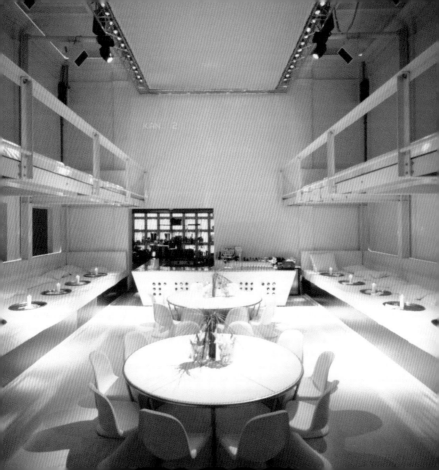

Noa Noodles Of Asia

Niek Swartjes

2002
Leidsegracht 84
Center

The equipment has been designed by the famous glass artist Niek Swartjes. All furniture has been custom-made for Noa. The silver leaf decorations and the wall paintings are perfect examples for the high-quality workmanship. The glass sculpture Mr. Noa adorns the entrance area of the restaurant.

Die Einrichtung wurde von dem berühmten Glaskünstler Niek Swartjes entworfen. Alle Möbel sind speziell für Noa entwickelt. Die hochwertige Ausführung zeigt sich exemplarisch an den silbernen Blattdekorationen und den Wandmalereien. Die Glasskulptur Mr. Noa ziert den Eingangsbereich des Restaurants.

L'ameublement a été conçu par le célèbre verrier d'art Niek Swartjes. Tous les meubles ont été créés spécialement pour Noa. Les décorations de feuilles argentées et les peintures murales sont des parfaits exemples de l'exécution de qualité supérieure. La sculpture de verre Mr. Noa orne la zone d'entrée du restaurant.

La decoración fue diseñada por el famoso artista en vidrios Niek Swartjes. Todos los muebles fueron creados especialmente para Noa. Las valiosas terminaciones se notan especialmente en las decoraciones laminadas en plata y los murales. La escultura en vidrio Mr. Noa decora el vestíbulo del restaurant.

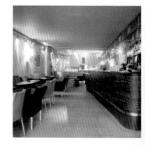

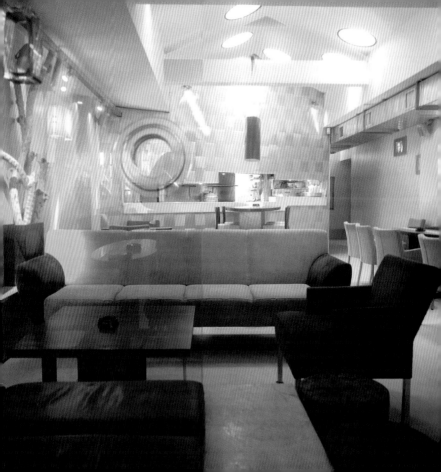

Nomads

Concrete Architectural Associates

2001
Rozengracht 133
Center

www.restaurantnomads.nl
www.concrete.archined.nl

Every guest, with the exception of vegetarians, gets the same menu. The meals are eaten the Arabian way, which means the guest sits on U-shaped mattresses in Oriental ambience. Every detail right down to the clothing of the staff has been matched to this motto. The DJ of the restaurant lures the dancers in a central temple-like shrine.

Jeder Gast, mit Ausnahme der Vegetarier, bekommt das gleiche Menu serviert. Gegessen wird Arabisches, der Besucher sitzt auf U-förmigen Matratzen in orientalischem Ambiente, auf das jedes Detail bis hin zur Kleidung der Belegschaft abgestimmt ist. Der hauseigene DJ lockt zum Tanz im zentralen, tempelartigen Schrein.

Chaque invité, à l'exception des végétariens, reçoit le même menu. Les plats sont mangés à l'arabe, ce qui signifie que le visiteur est assis sur des matelas en U dans une ambiance orientale. Chaque détail, jusqu'à la tenue du personnel, est assorti à ce thème. Le DJ de la maison attire les danseurs dans le haut lieu central décoré tel un temple.

A todos los huéspedes con excepción de los vegetarianos, se les sirve el mismo menú. La comida es árabe, el visitante se sienta sobre colchones en forma de U en un ambiente oriental en que todos los detalles armonizan, inclusive la vestimenta del personal. El DJ de la casa invita al baile en un cofre central semejante a un templo.

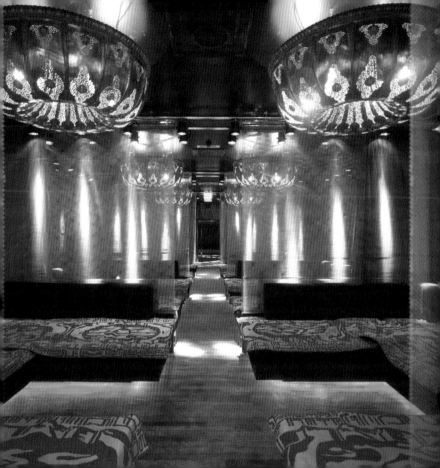

Morlang

Concrete Architectural Associates

2000
Keizersgracht 415
Center

www.concrete.archined.nl

The rooms are in sober white with wooden floors. The square concrete tables are surrounded by steel chairs by WH Gispen, which are covered by orange-colored corduroy like the benches along the walls. The liqueur cabinet is located behind the bar. In the basement the silver colored walls are decorated with lilies.

Die Räume präsentieren sich in nüchternem Weiß mit Holzböden. Um quadratische Betontische stehen Stahlstühle von WH Gispen, die wie die Bänke entlang der Wände mit orangefarbener Kordseide bezogen sind. Hinter der Bar befindet sich das Likörkabinett. Im Untergeschoss zieren Lilien silbern bemalte Wände.

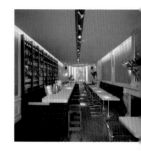

Les espaces sont d'un blanc sobre avec des planchers de bois. Les tables en béton carrées sont entourées de chaises en acier de WH Gispen qui sont recouvertes de velours côtelé comme les bancs longeant les murs. L'armoire à liqueurs se trouve derrière le bar. Les murs argentés du rez-de-chaussée sont décorés de lis.

Las habitaciones se presentan en un blanco sobrio con pisos de madera. Alrededor de mesas cuadradas de hormigón hay sillas de acero de WH Gispen, que están forradas en seda de pana color naranja, igual que los bancos instalados a lo largo de las paredes. Detrás del bar está el gabinete de licores. En el subterráneo lirios adornan las paredes plateadas.

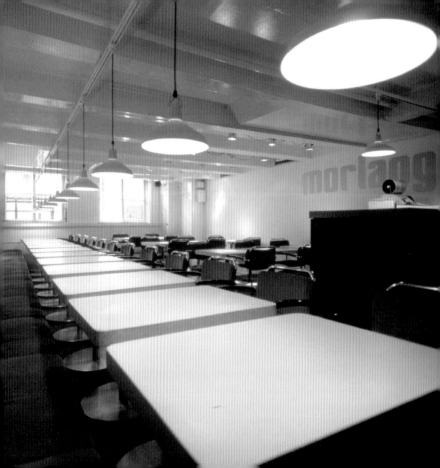

Jimmy Woo

Eric Kuster B. Inc

2003
Korte Leidsedwarsstraat 18
Center

www.jimmywoo.com

Gold leaf and black polished walls, Japanese lanterns and a real antique opium bed create an extraordinary ambience at Jimmy Woo's. A luminous ceiling consisting of over twelve thousand light spots hangs over the dance floor. An ultramodern sound system ensures the right atmosphere.

Blattgold und schwarze, polierte Wände, japanische Laternen und ein echtes antikes Opiumbett kreieren ein außergewöhnliches Ambiente in Jimmy Woo. Über der Tanzfläche schwebt eine Leuchtdecke aus über zwölftausend Lichtpunkten. Eine ultramoderne Soundanlage sorgt für die richtige Stimmung.

Des murs polis noirs et dorés à la feuille, des lanternes japonaises et un véritable lit d'opium antique créent une atmosphère exceptionnelle chez Jimmy Woo. Un plafond lumineux constitué de plus de douze milles points luminescents surplombe la piste de danse. Une installation audio ultramoderne assure une ambiance idéale.

Láminas de oro y paredes negras pulidas, linternas japonesas y una cama original de fumadores de opio, crean un ambiente extraordinario en Jimmy Woo. Sobre la pista de baile flota un cielo consistente de doce mil puntos luminosos. Un equipo de música ultramoderno crea el ambiente adecuado.

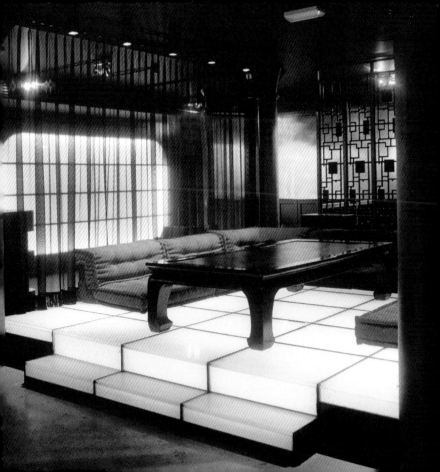

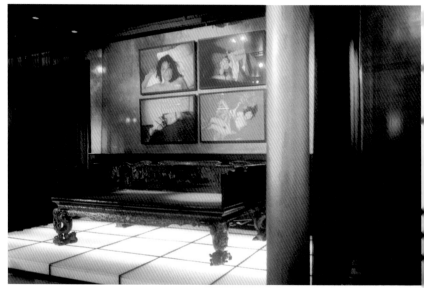

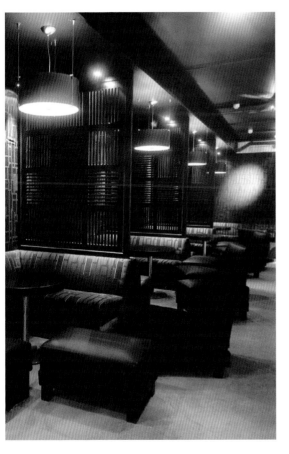

Plancius

Merkx+Girod architects

2001
Plantage Kerklaan 61
Oost

www.merkx-girod.nl

The café is part of a building from the 19th century which has been converted into a museum. A box has been placed in a high room which has left the characteristic ceiling untouched. The toilets and the kitchen behind it are separated at the back from the guests by a red upholstered wall.

Das Café ist Teil des Umbaus eines Gebäudes aus dem 19. Jahrhundert zum Museum. Eine Box ist in einen hohen Raum eingestellt, wodurch die charakteristische Decke unangetastet bleibt. Die rot gepolsterte Wand im Rücken der Gäste bietet Sichtschutz zu den Toiletten und zur dahinter liegenden Küche.

Le café est une partie du bâtiment du 19e siècle qui a été transformé en musée. Un caisson a été installé dans un espace haut qui garde le plafond caractéristique intact. Les toilettes et la cuisine à la derrière sont séparées des hôtes par un mur rembourré.

El café es parte de la transformación en museo de un edificio del siglo 19. Se ha instalado un box en una habitación alta, por lo que el cielo raso característico quedó intacto. La pared detrás de los huéspedes, forrada con tela roja, bloquea la vista hacia los baños y la cocina que está detrás.

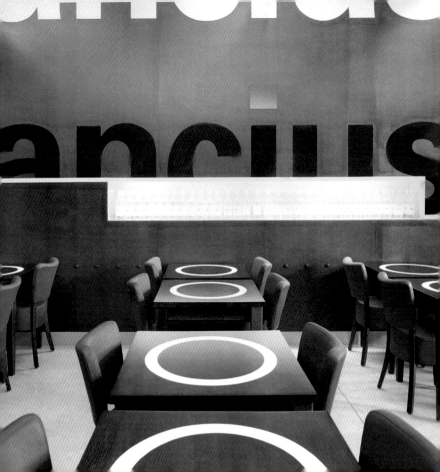

Blender

Concrete Architectural Associates

2000
Van der Palmkade 16
Westerpark

www.blender2001.com
www.concrete.archined.nl

The music plays during the dinner already; slowly but surely the DJ gets the guests going for the dance in the evening. Orange-colored bowl-shaped chairs are grouped around a central bar with an open-plan kitchen in an oval room. As a contrast crimson velvet curtains cover the walls and in addition serve as a sound insulation.

Schon zum Dinner spielt die Musik, der DJ bringt die Gäste langsam in Schwung für den nächtlichen Tanz. In dem ovalen Raum gruppieren sich orangefarbene Schalenstühle um eine zentrale Bar mit offener Küche. Als Kontrast bedecken purpurne Samtvorhänge die Wände und dienen zusätzlich als Schallisolierung.

La musique retentit déjà au dîner ; lentement mais sûrement, le DJ incite les hôtes à danser toute la soirée. Des chaises orange en forme de cuvette sont regroupées autour d'un bar central avec cuisine ouverte dans une pièce ovale. En guise de contraste, des rideaux de velours pourpres recouvrent les murs et font en outre office d'insonorisation.

Durante la comida ya hay música, el DJ anima poco a poco a los huéspedes para el baile nocturno. En la habitación ovalada se agrupan sillas moldeadas color naranja alrededor de un bar central con cocina abierta. Como contraste, las paredes están cubiertas con cortinas de terciopelo púrpura, que además sirven de aislación acústica.

Three Restaurants

Tangram Architekten
ING Vastgoed (SE)

2001
Meer en Vaart 79
Osdorp

www.tangramarchitekten.nl

Three levels of different shape and size are oriented in different directions. They give the building a strange appearance of wildly moved surfaces. Each level houses a restaurant with separate entrance each. The kitchens and toilets are situated in a joint core.

Drei Ebenen unterschiedlicher Form und Größe orientieren sich in verschiedene Richtungen. Sie geben dem Gebäude eine eigenartige Erscheinung aus wild bewegten Oberflächen. Jede Ebene beherbergt ein Restaurant mit jeweils eigenem Zugang. Küchen und Toiletten befinden sich in einem gemeinsamen Kern.

Trois niveaux de forme et de taille différentes s'orientent dans diverses directions. Ils confèrent au bâtiment une apparence unique de surfaces mobiles et « sauvages ». Chaque niveau abrite un restaurant avec un accès propre. Les cuisines et les toilettes se trouvent dans un noyau commun.

Tres niveles de distintas formas y tamaños se orientan en diferentes direcciones. Le dan un aspecto único al edificio, con superficies de movimiento violento. Cada nivel alberga un restaurante con acceso propio. Las cocinas y los baños se hallan en un núcleo común.

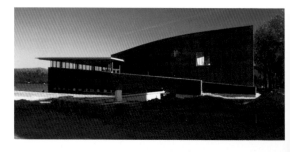

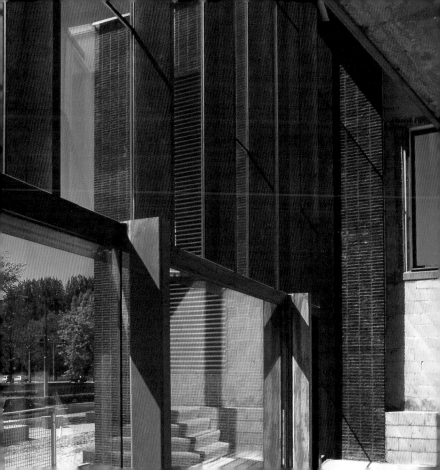

Vakzuid

Studio Linse

1999
Olympisch Stadion 35
Oud Zuid

www.vakzuid.nl

Irrespective of whether you are looking for a living room with a plush carpet or a cool bar in industrial design, you will have the choice in the converted catacombs of the old Olympic stadium. Staggered levels mark the various areas. Glass balustrades permit eye contacts and keep the impression of a large joint room.

Ob Wohnzimmer mit Plüschteppich oder coole Bar im Industriedesign – in den umgestalteten Katakomben des alten Olympiastadions hat man die Wahl. Versetzte Ebenen markieren die verschiedenen Bereiche. Glasbrüstungen gewähren Blickkontakte und bewahren den Eindruck eines großen, gemeinsamen Raumes.

Que vous recherchiez un salon avec tapis en peluche ou un bar branché de design industriel, vous aurez le choix dans les catacombes aménagées de l'ancien stade olympique. Des niveaux décalés marquent les différentes zones. Des balustrades en verre assurent le contact visuel et conservent l'impression d'un grand espace.

Trátese de habitaciones con suaves alfombras o de un bar con un frío diseño industrial – en las catacumbas del viejo estadio olímpico transformado se puede escoger. Niveles desplazados marcan los diferentes áreas. Barandas de vidrio dan visibilidad y mantienen la impresión de un gran espacio común.

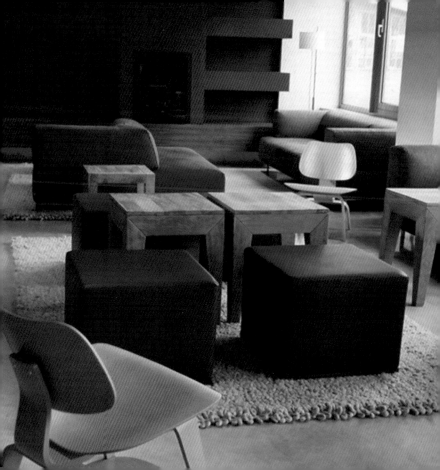

Restaurant De Kas

Piet Boon (SE)
Wassenaarse Bouwmaatschappij BV (SE)

2001
Kamerlingh Onneslaan 3
Watergraafsmeer

www.restaurantdekas.nl
www.pietboon.nl

The concealed restaurant turns out to be a real gem in busy urban life. In the very individual atmosphere of an ambitiously restored greenhouse from the beginning of the 20th century, the kitchen with international renown serves dishes composed of self-grown vegetables and of its own spices.

Das versteckte Restaurant entpuppt sich als wahres Kleinod im geschäftigen Stadtleben. In der eigenwilligen Atmosphäre eines anspruchsvoll restaurierten Gewächshauses vom Anfang des 20. Jahrhunderts serviert die Küche mit internationalem Renommee Speisen aus selbst angebautem Gemüse und eigenen Gewürzen.

Le restaurant dissimulé s'avère être un véritable petit bijou dans la vie citadine agitée. Dans l'atmosphère originale d'une serre restaurée avec raffinement du début du 20e siècle, la cuisine de renommé internationale sert des plats composés des légumes qu'ils cultivent et de leurs propres épices.

El restaurante escondido revela ser una verdadera joya en la vida agitada de la ciudad. En la atmósfera propia de un invernadero de comienzos del siglo 20, restaurado con refinado gusto, la cocina de reputación internacional sirve comida preparada con verduras y condimentos de producción propia.

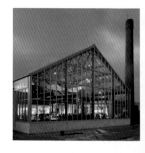

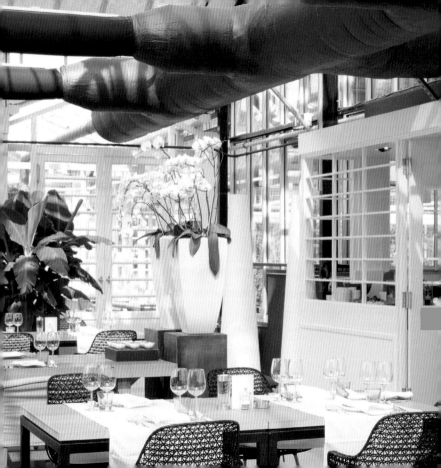

Cinema Het Ketelhuis

Witteveen Visch Architecten
Mark Helder (SE)

1999
Haarlemmerweg 8-10
Westerpark

www.ketelhuis.nl
www.witteveenvisch.nl

The seating is at an angle in the cinema: this seems to be the message of the rectangular wooden box which boldly pushes out of the floorboards of the old factory hall. As a separate object, the heart of the movie theatre breaks away from the ground plan and sets the hall with its barrel roof into an exciting relationship to the surrounding café.

Im Kino sitzt man schräg, scheint die rechteckige Holzkiste zu verkünden, die sich kühn aus dem Dielenboden der alten Fabrikhalle schiebt. Als eigenständiges Objekt löst sich das Herzstück des Filmtheaters vom Grundriss und setzt die Halle mit ihrem Tonnendach in aufregende Beziehung zum umgebenden Café.

Au cinéma, les sièges sont inclinés : c'est ce que semble annoncer la caisse de bois rectangulaire qui s'extrait audacieusement du plancher du hall de l'ancienne usine. La partie principale du cinéma se détache du plan horizontal en tant qu'objet indépendant et relie de façon attrayante le hall, avec son toit en berceau, au café attenant.

En el cine uno se sienta en declive, parece proclamar la caja de madera rectangular que se proyecta audazmente desde el suelo de madera de la nave de la antigua fábrica. Como objeto independiente el núcleo central del teatro se desprende del plano horizontal, y le otorga a la sala con su tejado en forma de tonel una relación exitante con el café que lo rodea.

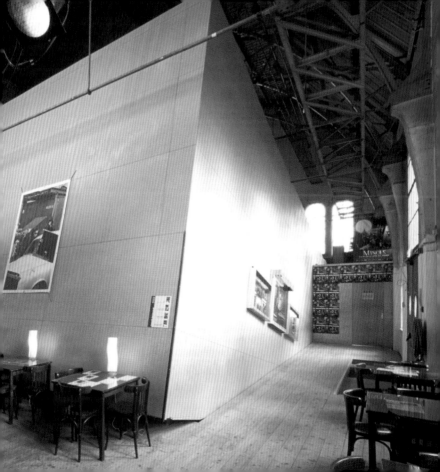

Cinecenter

NL Architects

1999
Lijnbaansgracht 236
Center

www.cinecenter.nl

Walls painted in black deceive the viewer about the unfavorable proportions of the renovated cinema. From a passage between two streets, the cinemagoer enters the foyer through a curtain draped with newspapers. A mirrored wall seems to double the size of the colorfully illuminated room with golden counters.

Schwarz gestrichene Wände täuschen über die ungünstigen Proportionen der renovierten Kinosäle hinweg. Aus einer Passage zwischen zwei Straßen betritt man das Foyer durch einen mit Zeitschriften drapierten Vorhang. Eine Spiegelwand scheint den bunt beleuchteten Raum mit goldenem Tresen zu verdoppeln.

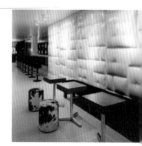

Des murs peints en noir masquent les proportions irrégulières des salles de cinéma rénovées. A la sortie d'un passage entre deux rues, le visiteur entre dans le foyer à travers un rideau drapé de journaux. Un mur miroir semble doubler la taille de la pièce aux couleurs lumineuses et aux comptoirs dorés.

Las paredes pintadas de negro hacen olvidar las proporciones poco afortunadas de las salas de cine renovadas. Se entra al foyer desde un pasaje entre dos calles por una cortina drapeada con revistas. Una muralla de espejos parece duplicar el espacio con mostrador dorado iluminado en múltiples colores.

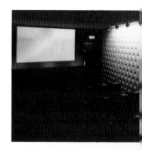

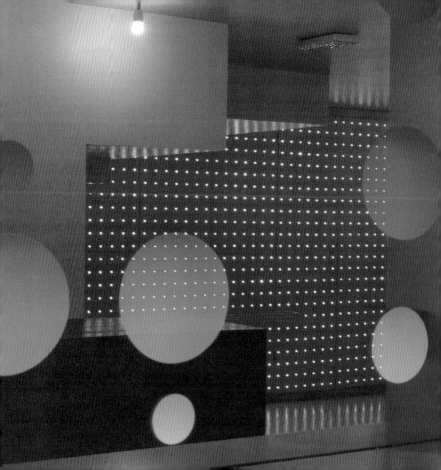

De Toekomst

A.F.C. Ajax

René van Architekten BV Zuuk
Eindhoven Van der Laar, Advies en Ingenieursbureau (SE)

1996
Borchlandweg 16-18
Duivendrecht

www.ajax.nl
www.renevanzuuk.nl

A "Factory for the Production of Soccer Players" is the heart of the youth work of Ajax Amsterdam. Whilst the massive base houses all functions of the sports facilities, the main rooms of the day home open up to the horizon, which symbolically consists of the football pitches of the young players.

Eine „Fabrik zur Produktion von Fußballern" ist das Herzstück in der Jugendarbeit Ajax Amsterdams. Während der massive Sockel alle dienenden Funktionen der Sportanlagen aufnimmt, öffnen sich die Haupträume des Tagesheimes zum Horizont, der sinnbildlich aus den Fußballplätzen der jungen Kicker besteht.

Une « Usine de production de footballeurs » est au centre du travail des jeunes de l'Ajax Amsterdam. Alors que la fondation massive abrite toutes les fonctions des installations sportives, les espaces principaux du domicile de jour s'ouvrent sur l'horizon composé symboliquement des terrains de football des jeunes joueurs.

Una "fábrica productora de futbolistas" es el núcleo central del trabajo juvenil Ajax de Amsterdam. Mientras que el zócalo masivo soporta todas las funciones deportivas, los espacios principales del hogar diurno se abren hacia el horizonte, que simbólicamente se compone de las canchas de fútbol de los jóvenes futbolistas.

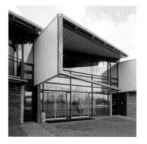

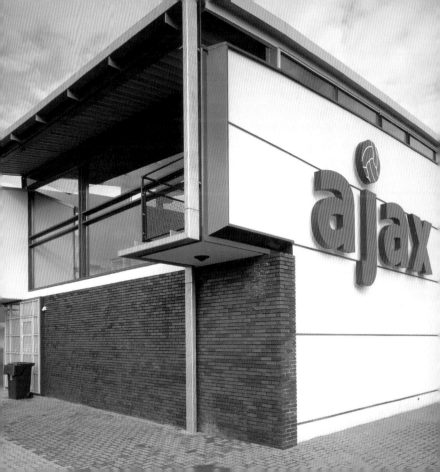

Sports Medical Center Olympiaplein

Hans van Heeswijk

2002
Olympiaplein Amsterdam
Oud-Zuid

www.heeswijk.nl

The building complex stands in the middle of the square in the "Olympiaplein" sports area like a big pavilion. Glass dominates the facades and gives the building a transparent appearance. Closed elements made of red bricks constitute the link to the historic buildings in the neighborhood.

Wie ein großer Pavillon steht der Gebäudekomplex in der Mitte eines Platzes im Sportareal Olympiaplein. Glas dominiert die Fassaden und gibt dem Gebäude eine transparente Erscheinung. Geschlossene Elemente aus Backstein bilden die Verbindung zu den historischen Gebäuden der Nachbarschaft.

Le complexe de bâtiment s'élève, tel un grand pavillon, au milieu d'une place dans l'aire sportive « Olympiaplein ». Le verre domine les façades et confère au bâtiment une apparence transparente. Des éléments fermés en brique rouge le relient aux bâtiments historiques des environs.

Como un gran pabellón se erige el complejo de edificios en el medio de una plaza en el área deportiva "Olympiaplein". El vidrio domina las fachadas y le da un aspecto transparente al edificio. Elementos compactos de ladrillo forman la conexión con los edificios históricos de la vecindad.

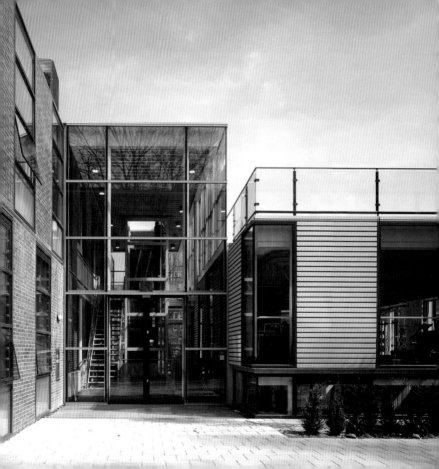

Amsterdam ArenA

Sjoerd Soeters

1996
ArenA Boulevard 1
Amsterdam Zuidoost

www.amsterdamarena.nl

The football stadium of Ajax Amsterdam can take up 50,000 spectators. The very steep stands rise above two parking levels. Apart from the computer-monitored growth of the lawn, the moveable roof at a height of 75 meters (82 yds.) is an expression of the latest technology. If required, the arena is converted into a monstrous hall.

50 000 Zuschauer fasst das reine Fußballstadion von Ajax Amsterdam. Über zwei Parkdecks erheben sich die sehr steilen Tribünen. Neben computerüberwachtem Rasenwuchs ist besonders das bewegliche Dach in 75 Meter Höhe Ausdruck modernster Technik. Bei Bedarf verwandelt es die Arena in eine monströse Halle.

Le stade de football de l'Ajax Amsterdam peut contenir 50 000 spectateurs. Les tribunes très abruptes surplombent deux niveaux de parking. Outre la pousse du gazon surveillée par ordinateur, le toit mobile haut de 75 mètres illustre particulièrement la technique à la pointe de la modernité. Au besoin, l'arène se transforme en un gigantesque hall.

El estadio puramente de fútbol de Ajax Amsterdam tiene una cabida de 50 000 espectadores. Sobre dos aparcamientos, se erigen las tribunas muy empinadas. Fuera del crecimiento del césped controlado por computadoras, el techo movible a 75 metros de altura es expresión de la tecnología más moderna. En caso necesario convierte la arena en una gigantesca sala.

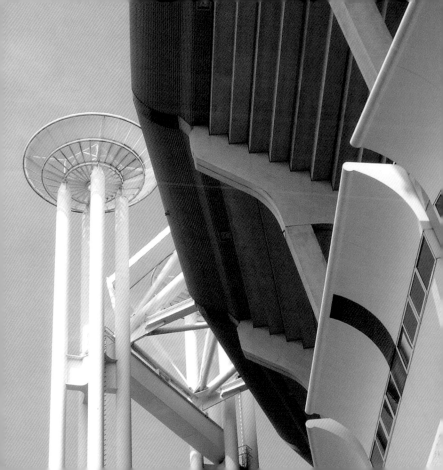

to shop . mall
retail
showrooms

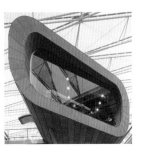
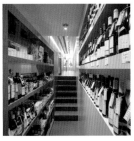

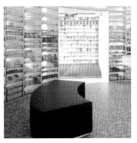
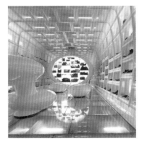
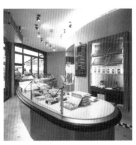
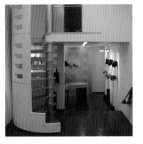
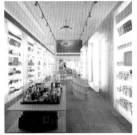

Baden Baden

Piet Boon (SE)

2000
Valkenburgerstraat 201a
Waterlooplein

www.pietboon.nl

The shop is the showpiece of the designer Piet Boon. In different exhibition areas, furnishing for bathrooms by the most important designers are offered as well as individual pieces by Piet Boon himself. A separate showroom presents models of top-class Italian furniture lines.

Der Laden ist das Vorzeigeobjekt des Designers Piet Boon. In unterschiedlichen Ausstellungsbereichen werden Einrichtungen für Badezimmer von den wichtigsten Designern ebenso angeboten wie die Einzelstücke von Piet Boon selbst. Ein separater Showroom zeigt Modelle italienischer Top-Möbellinien.

La boutique est l'objet modèle du designer Piet Boon. Dans diverses zones d'exposition, de l'ameublement pour salles de bains des plus grands designers est présenté, ainsi que des pièces uniques de Piet Boon lui-même. Une salle d'exposition séparée expose des modèles des marques de mobilier italiennes de haut de gamme.

La tienda es el objeto de exhibición del diseñador Piet Boon. En distintos lugares de exposición se ofrece instalaciones para baños creadas por los diseñadores más famosos, como también piezas individuales de Piet Boon mismo. Una sala de exposición separada, muestra modelos de líneas de muebles italianos top.

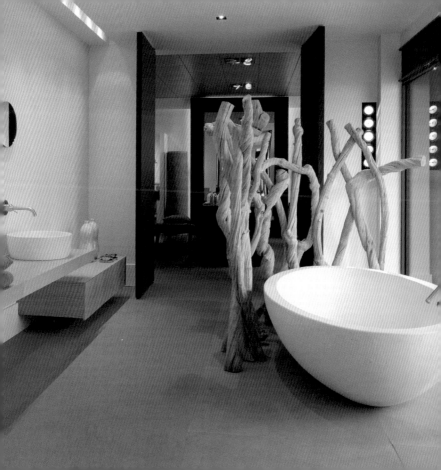

A-Markt

Verburg Hoogendijk Architekten
ABT West (SE)

1998
Rapenburg 91
Center

On account of the exposed position of the very narrow real estate, the light-weight temporary building receives a special significance in the urban surroundings. Behind a guard wall made of perforated steel, two separate office parts in the upper story form a natural graduation toward the adjacent buildings.

Durch die exponierte Lage des sehr schmalen Grundstücks erhält der in Leichtbauweise erstellte Temporärbau besondere Bedeutung im städtischen Umfeld. Hinter einer Schutzwand aus gelochtem Stahl bilden zwei getrennte Büroteile im Obergeschoss eine natürliche Staffelung zu den angrenzenden Gebäuden.

En raison de la situation exposée du terrain très étroit, le bâtiment provisoire de construction légère revêt une signification particulière dans l'environnement de la ville. Derrière un mur de protection en acier perforé, deux zones de bureaux séparées forment, à l'étage supérieur, une progression naturelle vers les bâtiments attenants.

La ubicación expuesta del terreno sumamente angosto, otorga un significado especial a la construcción temporal liviana dentro del entorno urbano. Detrás de una muralla protectora de acero perforado, dos sectores de oficinas separados en el piso superior, forman un escalonamiento natural hacia los edificios colindantes.

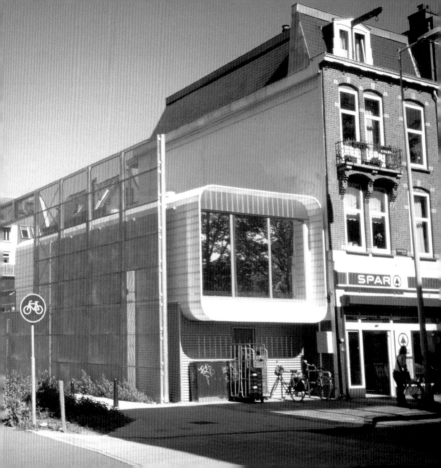

Mac Bike

Verburg Hoogendijk Architekten
ABT Delft (SE)

1997
Meester Visserplein
Center

www.vharch.nl

The sales pavilion for bicycles is situated above the entrance to an old underpass. The staircase and the tunnel have been converted into an exhibition area. Walls made of glass blocks and metal grating on the ceiling ensure transparency as well as safety. The glazed workshop can be seen in the basement.

Der Verkaufspavillon für Fahrräder steht über dem Eingang einer alten Unterführung. Treppe und Tunnel wurden zur Ausstellungsfläche umfunktioniert. Wände aus Glasbausteinen und Gitterrostabdeckungen über der Decke bieten sowohl Transparenz als auch Sicherheit. Im Untergeschoss sieht man die verglaste Werkstatt.

Le pavillon commercial pour cyclistes surplombe l'entrée d'un ancien passage souterrain. Les escaliers et le tunnel ont été transformés en espaces d'exposition. Les murs en briques de verre et les revêtements de grille du plafond assurent transparence et sécurité. Au rez-de-chaussée se trouve l'atelier vitré.

El pabellón de ventas para bicicletas está ubicado sobre la entrada de un viejo paso bajo nivel. Escalera y túnel se convirtieron en superficies de exposición. Murallas de ladrillos de vidrio y coberturas de parrillas de enrejado sobre el techo, ofrecen transparencia como también seguridad. En el piso bajo se ve el taller acristalado.

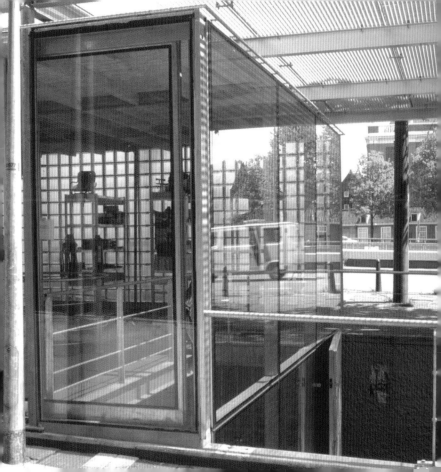

Jan Jansen Shop

Studio Swip Stolk
IDLite (SE)

2001
Rokin 42
Center

www.janjansenshoes.com

Swip Stolk developed the interior of the shoe shop after the motif of the time. Mobile propeller-shaped platforms permit the versatile design of the exhibition area. As if driving the numerous clocks on the wall, a pink-colored staircase stands in the room like a large wound-up clockwork.

Nach dem Motiv der Zeit hat Swip Stolk das Interieur des Schuhgeschäftes entwickelt. Bewegliche, propellerförmige Plattformen ermöglichen eine vielfältige Ausstellungsgestaltung. Als treibe sie die zahlreichen Uhren an den Wänden an, steht eine rosafarbene Treppe im Raum wie ein großes, aufgezogenes Uhrwerk.

Swip Stolk a développé l'intérieur du magasin de chaussures autour du thème du temps. Des plates-formes mobiles en forme d'hélices permettent une variété de dispositions pour la zone d'exposition. Comme s'il actionnait les nombreuses horloges murales, un escalier rose s'élève dans la pièce, tel une grande horloge démantelée.

Swip Stolk ha desarrollado el interior de la tienda de zapatos según el signo contemporáneo. Plataformas movibles, en forma de hélices, permiten múltiples presentaciones de exposición. Como si fuese impulsada por los innumerables relojes en las paredes, una escalera rosada se erige en el recinto como un gran mecanismo de reloj con cuerda.

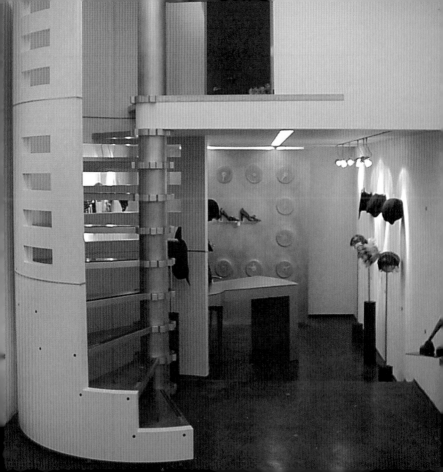

Rituals

Concrete Architectural Associates

2000
Kalverstraat 73
Center

www.rituals.com
www.concrete.archined.nl

Water as a linking element of all products offered is the initial design point for the open transparent presentation form of the shop. Bamboo is used to cover walls and floors; white shelves have a greenish gleam; and large windows open up the inner area towards the street.

Wasser als verbindendes Element aller angebotenen Produkte ist konzeptioneller Ausgangspunkt für die offene, transparente Präsentationsform des Ladens. Bambus dient als Boden- und Wandbelag, weiße Regale leuchten in grünlichem Schimmer, und große Fenster öffnen den Innenraum zur Straße.

L'eau, en tant qu'élément reliant tous les produits proposés, est le point de départ conceptuel de la forme de présentation transparente et ouverte de la boutique. Les bambous sont utilisés pour recouvrir le sol et les murs, des étagères blanches ont un éclat verdâtre et de grandes fenêtres s'ouvrent sur la rue.

El agua como elemento que vincula todos los productos ofrecidos, es el punto de partida para la forma abierta y transparente de presentación de la tienda. El bambú cubre suelos y paredes, estantes blancos brillan en resplandor verdoso, y grandes ventanales abren el espacio interior hacia la calle.

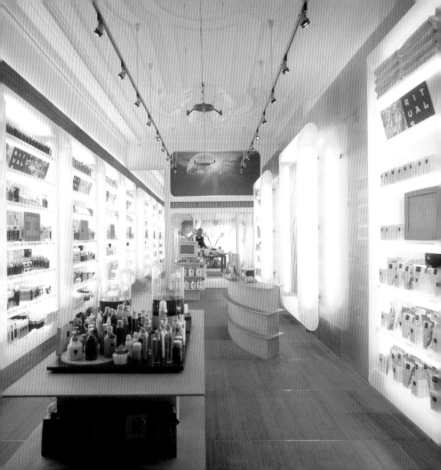

Australian

Concrete Architectural Associates

2002
Spui 5
Center

www.concrete.archined.nl

Shimmering in green like a polished glacier, the glass blocks produce an inviting atmosphere along with the steel of the sidewall and the light-gray floor. At the counter made of black stone and white marble the guests are served ice and chocolate in stainless steel cups.

Grün schimmernd wie ein polierter Gletscher, sorgen Glasbausteine zusammen mit dem Stahl der Seitenwand und dem hellgrauen Boden für eine einladende Atmosphäre. Am Tresen aus schwarzem Stein und weißem Marmor wird den Gästen Eis und Schokolade aus Edelstahlschalen serviert.

D'un vert étincelant tel un glacier poli, les briques de verre produisent une atmosphère accueillante avec l'acier des murs latéraux et le sol gris clair. Au comptoir en pierre noire et en marbre blanc, de la glace et du chocolat sont servis dans des coupes en acier inoxydable.

Ladrillos de vidrio que emiten reflejos verdes como los de un glaciar pulido, en conjunto con el acero de la pared lateral y el piso gris claro, crean una atmósfera atractiva. En el mostrador de piedra negra y mármol blanco se sirve a los clientes helados y chocolate en vasos de acero inoxidable.

Art and Fashion

Quirien Aretz

2003
Herengracht 259
Center

www.artandfashion.nl

Art and fashion from Brazil form an entity in the renovated rooms of a Jugendstil building on Herengracht. With more than four hundred old ceiling beams and small details, such as historic candle niches in the walls, the long white room produces a feeling of increased value.

Kunst und Mode aus Brasilien bilden eine Einheit in den renovierten Räumlichkeiten eines Jugendstilgebäudes an der Herengracht. Mit über 400 alten Deckenbalken und kleinen Details wie historische Kerzennischen in den Wänden vermittelt der lange, weiße Raum ein Gefühl von gewachsenem Wert.

L'art et la mode du Brésil forment une unité dans les locaux rénovés d'un bâtiment du style nouveau au bord du Herengracht. Avec plus de 400 poutres de plafond anciennes et des petits détails tels que des niches pour bougies historiques dans les murs, la pièce blanche longue et spacieuse diffuse un sentiment de grande valeur.

El arte y la moda del Brasil forman una unidad en los recintos renovados de un edificio del estilo modernista en la Herengracht. Con más de 400 vigas de techo y pequeños detalles como nichos históricos para velas en las paredes, la habitación larga y blanca transmite un sentido de valor creciente.

Weekend Company

Concrete Architectural Associates

2003
Singel 540
Center

www.weekendcompany.nl
www.concrete.archined.nl

A slightly distorted orange-red tunnel leads directly into a weekend holiday, so to speak. At the end a case logo symbolically shines on a semi-transparent wall. In the middle of the tunnel, a door leads into the consultation room; opposite customers can use computer terminals to plan their weekend themselves.

Ein leicht verzerrter orangeroter Tunnel führt sozusagen direkt in den Wochenendurlaub. Symbolisch leuchtet am Ende ein Koffer-Logo auf einer semitransparenten Wand. In der Mitte des Tunnels führt eine Tür ins Beratungszimmer. Gegenüber können Kunden an Computerterminals selbst ihr Wochenende planen.

Un tunnel orange légèrement déformé mène pour ainsi dire directement à la détente du week-end. A la fin du tunnel, un logo en valise scintille symboliquement sur un mur semi-transparent. Au milieu du tunnel, une porte mène à la chambre du conseil. Les clients d'en face peuvent planifier eux-mêmes leur week-end sur des terminaux informatiques.

Un túnel naranja ligeramente deformado lleva directamente a las vacaciones de fin de semana. El logotipo de una maleta brilla en el fondo en una muralla semitransparente. En la mitad del túnel, una puerta lleva a la sala de conferencias. Al frente los clientes pueden planificar por sí mismo el fin de semana en el terminal de computación.

Fishes

Studio Linse

2002
Utrechtsestraat 98
Center

www.fishes.nl

Long and slithery like the fish on the counter: Cool strip-line light fixtures increase the effect of depth in the very narrow room and are reflected from the polished surfaces of the walls. Only the red meat of the fish has a color in the completely white minimalist interior of the distinguished boutique.

Lang und glitschig wie die Fische im Tresen: Kühle Lichtbänder verstärken die Tiefenwirkung des sehr schmalen Raumes und werden von den glatt polierten Oberflächen der Wände reflektiert. Im völlig weißen, minimalistischen Interieur der vornehmen Boutique ist nur das rote Fleisch der Fische farbig.

Longs et glissants tels les poissons au comptoir, des rubans lumineux frais renforcent l'effet de profondeur de la très étroite pièce et sont réfléchis par les surfaces polies des murs. Dans la boutique élégante au décor entièrement blanc et minimaliste, seuls les poissons rouges sont colorés.

Largos y resbalosos como los peces en el mostrador: frías hileras luminosas aumentan el efecto de profundidad del recinto sumamente angosto y son reflejados por las superficies pulidas de las paredes. En el interior minimalístico totalmente blanco de la conocida boutique, sólo la roja carne de los pescados tiene color.

Shoebaloo

Meyer en van Schooten Architecten

2003
P.C. Hooftstraat 80
Center

The black glass of the shop windows reflects the passers-by; the floating silhouettes of the shoes can only be guessed. A futuristic world of colored light opens up behind. 540 fluorescent lamps behind translucent plastic walls provide continuously changing color atmospheres.

Im schwarzen Glas der Schaufenster spiegeln sich die Passanten, die schwebenden Silhouetten der Schuhe sind nur zu erahnen. Dahinter tut sich eine futuristische Welt aus buntem Licht auf. Hinter transluzenten Kunststoffwänden sorgen 540 Leuchtstoffröhren für ständig wechselnde Farbstimmungen.

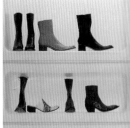

La vitre noire de la vitrine reflète les passants, que l'on devine uniquement à la silhouette aérienne de leurs chaussures. Derrière cette vitrine s'ouvre un monde futuriste tout en couleurs lumineuses. Derrière des parois de plastique translucides, 540 lampes fluorescentes assurent la variation constante des ambiances colorées.

En el vidrio negro del escaparate se reflejan los peatones, y las siluetas flotantes de los zapatos apenas se presienten. Atrás se abre un mundo futurístico de luz multicolor. Detrás de paredes de material sintético transparente, 540 tubos flourescentes producen un ambiente de colores cambiantes.

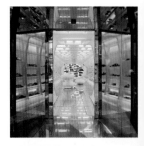

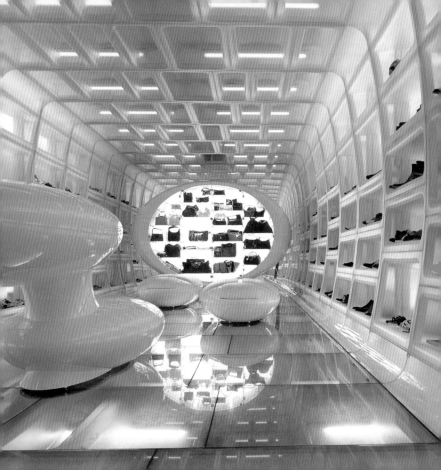

Lairesse Apotheek

Drugstore

Concrete Architectural Associates

2002
de Lairesse straat 40 hs
Center

www.delairesseapotheek.nl
www.concrete.archined.nl

The main attraction of the chemist's is a round room with a wall-high drawer cabinet made of green acrylic glass illuminated from the back. The white colored wooden counter contrasts well. Together with the leaf motif in the floor, a greenish shimmer is produced in the light of the translucent ceiling.

Hauptattraktion der Apotheke ist ein runder Raum mit einem wandhohen, von hinten beleuchteten Schubladenkabinett aus grünem Plexiglas. Davor hebt sich der weiß gestrichene Holztresen ab. Zusammen mit den Blattmotiven am Boden entsteht ein grünlicher Schimmer im Licht der transluzenten Decke.

L'attraction principale de la pharmacie est une pièce ronde avec une armoire à tiroirs en plexiglas vert de la hauteur du mur et éclairée de l'arrière, avec laquelle contraste le comptoir de bois peint en blanc. Avec les motifs de feuilles sur le sol, une lueur verte est produite dans l'éclairage du plafond translucide.

La atracción principal de la farmacia es una habitación redonda con un gabinete de cajones de plexiglás verde. Delante de éste se destaca el mostrador blanco de madera. Junto con los motivos de hojas del piso, se produce un reflejo verdoso con la luz del cielo raso transparente.

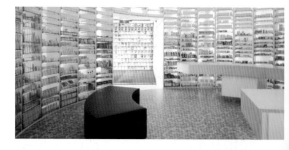

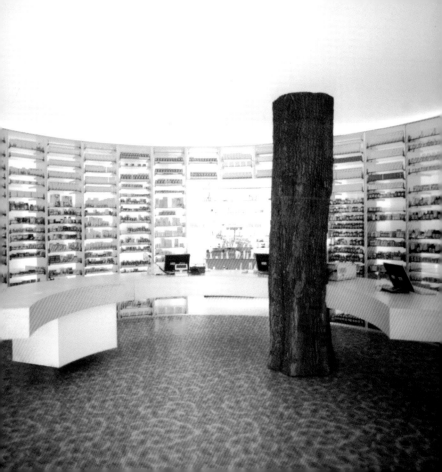

Villa ArenA

Benthem Crouwel Architekten BV bna
Ingenieursgroep van Rossum BV (SE)

2001
Entree 1
Amsterdam Zuidoost

www.villaarena.nl
www.benthemcrouwel.nl

By means of lifts from the parking level in the 5th and 6th story, the visitors descend to the sales floors in a central atrium. Bridges and escalators are used for additional short-cuts. On account of the spiraled arrangement, the storys give the impression of dynamics and movement.

Von den Parkebenen im 5. und 6. Geschoss gelangen die Besucher mittels Aufzügen in einem zentralen Atrium über die Verkaufsebenen nach unten. Brücken und Rolltreppen bilden zusätzliche Short-Cuts. Durch ihre gedrehte Anordnung erzeugen die Geschossebenen den Eindruck von Dynamik und Bewegung.

Au moyen d'ascenseurs depuis le niveau de parking du 5e et 6e étage, les visiteurs rejoignent les étages commerciaux par un atrium central. Les ponts et les escalators offrent des raccourcis supplémentaires. La disposition en spirale des étages produit un effet de dynamique et de mouvement.

Desde los aparcamentos en los pisos 5 y 6, los visitantes llegan en ascensores a un atrio central por los niveles de venta hacia abajo. Puentes y escaleras mecánicas forman short-cuts adicionales. Por su disposición los niveles de los pisos dan una impresión de dinámica y movimiento.

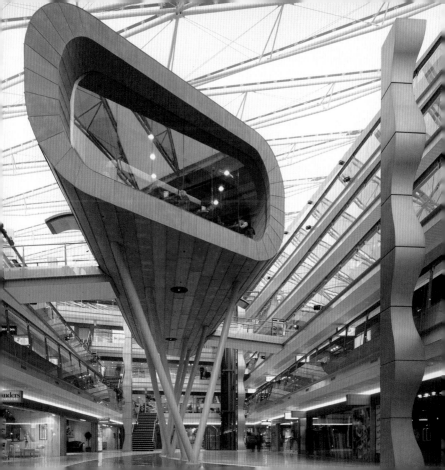

Index Architects / Designers

Name	Location	Page
Aretz, Quirien	Art and Fashion	168
Atelier Zeinstra		
van der Pol BV	Timorplein /	
	Borneodriehoek	36
	Depot Scheepvaart	
	Museum	70
Attika Architekten	Visitor Center IJburg	80
Bekkering, Juliette		
Architecten	Booster Pumstation	10
Berlage	Hotel V	114
Claus en Kaan		
Architecten	Hoogte Kadijk	
	and Laagte Kadijk	16
	Hall of Residence	
	Sarphatistraat	18
	Eurotwin	
	Business Center	44
	Zorgvlied Cemetery	100
Concrete		
Architectural Ass.	Supperclub	
	Amsterdam	122
	Nomads	126
	Morlang	128
	Blender	136
	Rituals	164
	Australian	166
	Weekend Company	170
	Lairesse Apotheek	176
Crouwel, Benthem		
Architekten		
BV bna	World Trade Center	
	Schiphol	60
	Anne Frank Museum	68
	Station Island	88
	Villa ArenA	178
De Arichtektengroep	Borneo Housing	20
	Bredero College School	
	Extension	72

Name	Location	Page
Diener & Diener		
Architekten	KNSM-	
	and Java Eiland	28
Dumoffice	Emma Church	82
Espinosa, Mirjam	Hotel V	114
Grimshaw	IJburg Bridges	92
Heeswijk, Hans van	Sports Medical Center	
	Olympiaplein	150
Hempel, Anouska	Blakes Hotel	106
Heren 5 architecten	Kavel 37	24
	Hoytema Residence	34
Hoofd, Ronald	Hotel V	114
	Hotel Arena	116
IDing	Hotel Arena	116
Jansen, Jaqu	De taart van m'n tante	9
Jong, Siemon de	De taart van m'n tante	9
Jongerius, Bastiaan	Loftice	40
Kien, Mary	Kien Bed	
	and Breakfast	110
Kohn Pedersen Fox		
Associates PA	World Trade Center	
	Amsterdam	50
Kuster, Eric B. Inc	Jimmy Woo	130
Merkx+Girod		
architects	Concert Hall	
	Renovation	78
	Plancius	134
Meyer en		
van Schooten	ING Group	
Architecten	Headquarters	54
	Nicolaas Maesschool	76
	Pakhuis Amsterdam	42
	Shoebaloo	174
Miclescu, Colpacci		
architects	Hotel de Filosoof	
	Renovation	112
MVRDV	Silodam	14

Name	Location	Page
NIO architecten	Bus Station Hoofddorp	102
NL Architects	Cinecenter	146
Oever, van den, Zaaijer & Partners architecten	Office Building Oficio	58
Offer, Noam	De taart van m'n tante	9
Piano, Renzo Building Workshop	New Metropolis	66
Piet Boon	Restaurant De Kas	142
	Baden Baden	156
Pol, Liesbeth van der	Depot Scheepvaart Museum	70
Prast, Herman Architect	Brasserie Harkema	120
Skidmore Owings & Merrill Inc	Apollo Building	48
	Philips Headquarters	52
Soeters, Sjoerd	Amsterdam ArenA	152
Studio Linse	Vakzuid	140
	Fishes	172
Studio Swip Stolk	Jan Jansen Shop	162
Studio van Boven	Hotel Arena	116
Swartjes, Niek	Noa Noodles Of Asia	124
Tangram Architekten	Waterdwellings	30
	Dukaat	32
	Primary School Horizon	74
	Three Restaurants	138
UN Studio	Watervillas Almere	38
	La Defense Almere	62
	Living Tomorrow Pavilion	84
	Piet Hein Tunnel	96
Uytenhaak, Rudy	Hoop, Liefde en Fortuin	22
	Patio Malaparte	26

Name	Location	Page
Uytenhaak, Rudy Architectenbureau BV	Hoop, Liefde en Fortuin	22
	Patio Malaparte	26
Valk, Kees van der	Hotel Seven One Seven	108
Verburg Hoogendijk Architekten	Evenementen Brug	98
	A-Markt	158
	Mac Bike	160
Visser, Martin	Hotel Arena	116
VMX Architects	Bicycle Storage	90
West8 urban design & landscape architecture bv	Borneo Sporenburg Bridges	94
	Ogilvy Group Nederland bv	46
	Cinema Het Ketelhuis	144
Zaag, Engbert van der	Hoop, Liefde en Fortuin	22
	Patio Malaparte	26
Zeinstra, Herman	Timorplein / Borneodriehoek	36
Zuuk, René van Architekten BV	Arcam Architectural Center	64
	De Toekomst, A.F.C. Ajax	148

Index Structural Engineers

Name	Location	Page
ABT Delft	Loftice	40
	Anne Frank Museum	68
	School of Business	86
	Evenementen Brug	98
	Mac Bike	160
ABT Arnhem	Pakhuis Amsterdam	42
ABT West	A-Markt	158
Aronsohn Raadgevende Ingenieurs BV	ING Group Headquarters	54
Boon, Piet	Restaurant De Kaas	142
	Baden Baden	156
Council of Amsterdam-Osdorp	Primary School Horizon	74
DRK	Emma Church	82
DWR Ingenieursbureau	Booster Pumstation	10
Eesteren, J.P. van BV	Bredero College School Extension	72
Engiplast	Bus Station Hoofddorp	102
Executive Architects Living Tomorrow	Living Tomorrow Pavilion	84
Government Buildings Department	Depot Scheepvaart Museum	70
Helder, Mark	Cinema Het Ketelhuis	144
IDLite	Jan Jansen Shop	162
Ingenieurs Bureau Amsterdam & WS Atkins Oxford	IJburg Bridges	92
JVZ Raadgevend Ingenieursburo	La Defense Almere	62
Laar, Advies en Ingenieursbureau Van der, Eindhoven	Arcam Architectural Center	64
	De Toekomst, A.F.C. Ajax	148
Ooms Bouw-maatschappij	Visitor Center IJburg	80
Pieters Bouwtechniek	Silodam	14
	Hoop, Liefde en Fortuin	22
	Patio Malaparte	26
Rossum, van BV Ingenieursgroep	KNSM- and Java Eiland	28
	Watervillas Almere	38
	Apollo Building	48
	World Trade Center Amsterdam	50
	Nicolaas Maesschool	76
	Villa ArenA	178
S.A.T Enigeering	Piet Hein Tunnel	96
SBDN	Waterdwellings	30
Smit's Bouwbedrijf	Borneo Housing	20
SOM	Philips Headquarters	52
Strackee	Timorplein / Borneodriehoek	36
Vastgoed, ING	Dukaat	32
	Three Restaurants	138
Vorm, van der Engineering Maarssen	Office Building Oficio	58
Wassenaarse Bouw-maatschappij BV	Restaurant De Kas	142
Weger, Bureau de	World Trade Center Schiphol	60
Zonneveld Ingenieursbureau	Bus Station Hoofddorp	102

Index Districts

District	No.	Building / Location	Address	Page
Almere	26	La Defense Almere	Willem Dreesweg 14–24	62
Almere-Buiten	15	Watervillas Almere	Eilandenbuurt	38
Amsterdam Noord	18	Eurotwin Business Center	Papaverweg	44
	31	Bredero College School Extension	Meeuwenlaan	72
Amsterdam Oost	22	Philips Headquarters	Amstelplein 2	52
	52	Hotel Arena	S´Gravesandestraat 51	116
Amsterdam Southeast	24	Office Building Oficio	Paasheuvelweg 1	58
	38	School of Business	Fraijlemaborg 133	
			Burg. Stramanweg	86
Amsterdam Zuid	23	ING Group Headquarters	Amstelveenseweg 500	54
	45	Zorgvlied Cemetery	Amsteldijk 273	100
Amsterdam Zuidoost	37	Living Tomorrow Pavilion	De Entree 300	84
	68	Amsterdam ArenA	ArenA Boulevard 1	152
	80	Villa ArenA	Entree 1	178
Borneo-Sporenburg	06	Borneo Housing	Stuurmankade /	
			Scheepstimmermanstraat	20
	07	Hoop, Liefde en Fortuin	Rietlandenterras 2–54,	
			Borneolaan 1–327	22
	08	Kavel 37	Scheepstimmermanstraat	24
	09	Patio Malaparte	Feike de Boerlaan / Borneokade /	
			Hofmeesterstraat	26
	10	KNSM- and Java Eiland	Bogortuin 109	28
	42	Borneo Sporenburg Bridges	Stuurmankade / Panamakade	94
Center	03	Silodam	Silodam	14
	04	Hoogte Kadijk and Laagte Kadijk	Hoogte Kadijk 21, 28	
			Laagte Kadijk 12–14, 30–33	16
	05	Hall of Residence Sarphatistraat	Sarphatistraat 143–159	18
	16	Loftice	de Ruijterkade 112	40
	27	Arcam Architectural Center	Prins Hendrikkade 600	64
	28	New Metropolis	Oosterdok 2	66
	29	Anne Frank Museum	Westermarkt 10	68
	30	Depot Scheepvaart Museum	Kattenburgerstraat 7	70
	33	Nicolaas Maesschool	Nicolaas Maesstraat 124–126	76
	39	Station Island	Central Station	88
	40	Bicycle Storage	Stationsplein	90
	43	Piet Hein Tunnel	Oosterdok and Zeeburg	96
	47	Blakes Hotel	Kreizersgracht 384	106

Index Districts

District	No.	Building / Location	Address	Page
Center	48	Hotel Seven One Seven	Prinsengracht 717	108
	49	Kien Bed and Breakfast	2e Weteringdwarsstraat 65	110
	50	Hotel de Filosoof Renovation	Anna van den Vondelstraat 6	112
	53	Brasserie Harkema	Nes 67	120
	54	Supperclub Amsterdam	Jonge Roelensteeg 21	122
	55	Noa Noodles Of Asia	Leidsegracht 84	124
	56	Nomads	Rozengracht 133	126
	57	Morlang	Keizersgracht 415	128
	58	Jimmy Woo	Korte Leidsedwarsstraat 18	130
	65	Cinecenter	Lijnbaansgracht 236	146
	70	A-Markt	Rapenburg 91	158
	71	Mac Bike	Meester Visserplein	160
	72	Jan Jansen Shop	Rokin 42	162
	73	Rituals	Kalverstraat 73	164
	74	Australian	Spui 5	166
	75	Art and Fashion	Herengracht 259	168
	76	Weekend Company	Singel 540	170
	77	Fishes	Utrechtsestraat 98	172
	78	Shoebaloo	P.C. Hooftstraat 80	174
	79	Lairesse Apotheek	de Lairesse straat 40 hs	176
Centrumeiland	41	IJburg Bridges	Pampuslan	92
De Pijp	01	De taart van m'n tante	Ferdinand Bolstraat 10/part	9
	20	Apollo Building	Apollo Laan 150	48
	21	World Trade Center Amsterdam	Strawinskylaan 1	50
	51	Hotel V	Victorieplein 42	114
Duivendrecht	66	De Toekomst, A.F.C. Ajax	Borchlandweg 16–18	148
Hoofddorp	46	Bus Station Hoofddorp	Voorplein Spaarneziekenhuis	102
Oost	59	Plancius	Plantage Kerklaan 61	134
Osdorp	11	Waterdwellings	Schillingdijk	30
	12	Dukaat	Pieter Calandlaan	32
	32	Primary School Horizon	Pieter Calandlaan 768	74
	61	Three Restaurants	Meer en Vaart 79	138
Oud Zuid	19	Ogilvy Group Nederland bv	Pilotenstraat 41	46
	34	Renovation Concert Hall	Concertgebouwplein 2–6	78
	62	Vakzuid	Olympisch Stadion 35	140
	67	Sports Medical Center Olympiaplein	Olympiaplein Amsterdam	150

District	No.	Building / Location	Address	Page
Overtoomse Veld	13	Hoytema Residence	Th. Van Hoytemastraat / Derkinderenstraat	34
Schiphol	25	World Trade Center Schiphol	Airport Schiphol	60
Stadsried-Landen	17	Pakhuis Amsterdam	Oostelijke Handelskade 17	42
Watergraafsmeer	36	Emma Church	Hugo de Vrieslaan 2	82
	63	Restaurant De Kas	Kamerlingh Onneslaan 3	142
Waterlooplein	69	Baden Baden	Valkenburgerstraat 201a	156
Westerpark	60	Blender	Van der Palmkade 16	136
	64	Cinema Het Ketelhuis	Haarlemmerweg 8–10	144
Zeeburgereiland	02	Booster Pumstation	Zuiderzeeweg 10	10
	14	Timorplein / Borneodriehoek	Timorplein / Borneostraat / Delistraat	36
	35	Visitor Center IJburg	IJdijk 50	80
Zuidoost	44	Evenementen Brug	Amsterdam ArenA	98

Photo Credits

Aldershoff, Roos	78, 79, 134, 135
Arcaid, Richard Bryant	48, 49, 52, 53
Aretz, Quirien	168,169
Attika Architekten	80, 81
Bachmann, Markus	14, 15, 16, 17, 18, 19, 20, 21, 28, 29, 38, 39, 44, 45, 62, 63, 72, 73, 86, 87, 92, 93, 94, 95, 96, 97, 100, 101, 110, 111, 114, 115, 116, 152, 153
Bekkering, Juliette Architecten	10
Concrete Architectural Associates	122, 126, 128, 129, 136, 137, 164, 165, 166, 167, 170, 171
Crouwel, Benthem Architekten	88, 89
Denancé, Michel	66, 67
Derwig, Jan	58, 59, 76, 175
Esch, H.G.	50, 51
Esch, Jan van	22, 23
Fessy, Georges	54, 55
Heins, Matthys	142, 143, 156, 157
Hempel, A. Management Ltd.	106, 107
Henselmans, Sjaak	50
Hummel, Kees	24, 25, 34, 35
Jonker & Wu	158
Kramer, Luuk	26, 27, 40, 41, 77, 150, 151, 42
Kranendonk, Sigurd	140, 141
Krijgsman, Teo	172, 173
Linders, Jannes	60, 61, 68, 69, 178, 179
Marshall, John Lewis	30, 31, 32, 33, 74, 75, 138, 139
Musch, Jeroen	46, 47, 90, 144, 145, 176, 177
Pattist, Hans	102, 103
Princen, Bas	82, 83
Roon, Matthijs van	82
Rooy, Ton de	98, 99
Ruigrok, Wim	64, 65, 148, 149
Sabelis, Peter	9
Schmitz, Arjen	70, 71, 146, 147
Schrofer, Gilian	122, 123, 126, 127
Swip Stolk	162, 163
Uytenhaak, Rudy	22
Uytenhaak, Theo	22
Verburg Hoogendijk Architekten	98, 158, 159
Zeinstra, Herman	36, 37
Courtesy Brasserie Harkema	120, 121
Courtesy Hotel Arena	116
Courtesy Hotel de Filosoof	112, 113
Courtesy Hotel Seven One Seven	108, 109
Courtesy Jimmy Woo	130, 131
Courtesy Living Tomorrow Pavilion	84, 85
Courtesy Noa Noodles Of Asia	124, 125

Imprint

Copyright © 2004 teNeues Verlag GmbH & Co. KG, Kempen

teNeues Book Division
Kaistraße 18
40221 Düsseldorf, Germany
Phone: 0049-(0)211-99 45 97-0
Fax: 0049-(0)211-99 45 97-40
E-mail: books@teneues.de

Press department: arehn@teneues.de
Phone: 0049-(0)2152-916-202

www.teneues.com
ISBN 3-8238-4583-7

teNeues Publishing Company
16 West 22nd Street
New York, N.Y. 10010, USA
Phone: 001-212-627-9090
Fax: 001-212-627-9511

teNeues Publishing UK Ltd.
P.O. Box 402
West Byfleet
KT14 7ZF, UK
Phone: 0044-1932-403 509
Fax: 0044-1932-403 514

teNeues France S.A.R.L.
4, rue de Valence
75005 Paris, France
Phone: 0033-1-55 76 62 05
Fax: 0033-1-55 76 64 19

Bibliographic information published by Die Deutsche Bibliothek
Die Deutsche Bibliothek lists this publication in the Deutsche Nationalbibliografie;
detailed bibliographic data is available in the Internet at http://dnb.ddb.de

Editorial Project: fusion-publishing GmbH www.fusion-publishing.com
Edited by Sabina Marreiros
Concept by Martin Nicholas Kunz
Layout & Pre-press: Thomas Hausberg
Imaging: Jan Hausberg
Maps: go4media. – Verlagsbüro, Stuttgart

Translation: ADE-Team
English: Robert Chengab
French: Birgit Allain
Spanish: Margarita Celdràn-Kuhl

Printed in Italy

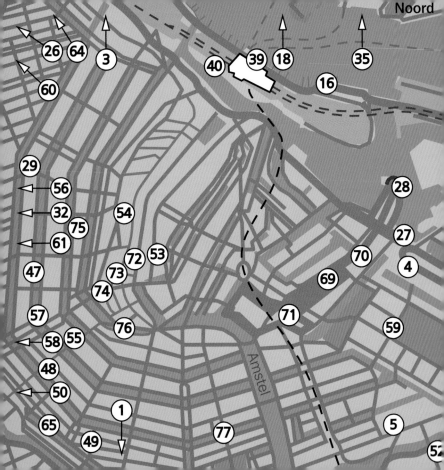

Noord

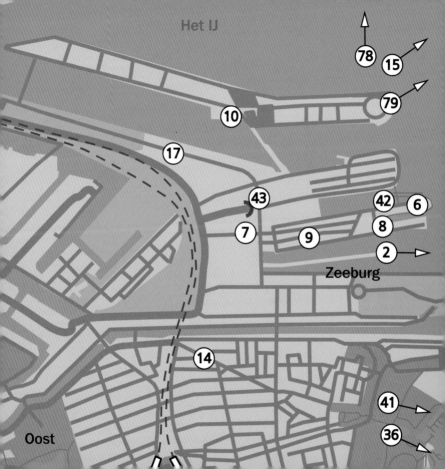

Het IJ

78 15

79

10

17

43

42 6

7

8

9

2

Zeeburg

14

41

36

Oost

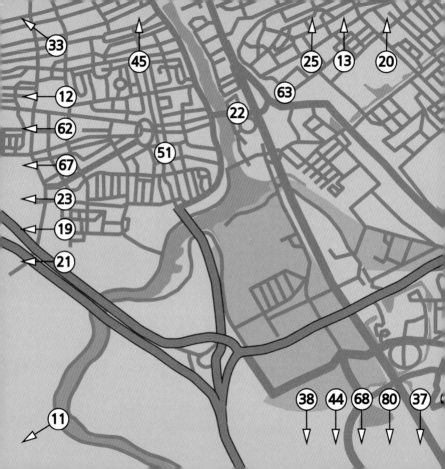

Legend

01	De taart van m'n tante	9
02	Booster Pumstation East	10
03	Silodam	14
04	Hoogte Kadijk and Laagte Kadijk	16
05	Hall of Residence Sarphatistraat	18
06	Borneo Housing	20
07	Hoop, Liefde en Fortuin	22
08	Kavel 37	24
09	Patio Malaparte	26
10	KNSM- and Java Eiland	28
11	Waterdwellings	30
12	Dukaat	32
13	Hoytema Residence	34
14	Timorplein / Borneodriehoek	36
15	Watervillas Almere	38
16	Loftice	40
17	Pakhuis Amsterdam	42
18	Eurotwin Business Center	44
19	Ogilvy Group Nederland bv	46
20	Apollo Building	48
21	World Trade Center Amsterdam	50
22	Philips Headquarters	52
23	ING Group Headquarters	54
24	Office Building Oficio	58
25	World Trade Center Schiphol	60
26	La Defense Almere	62
27	Arcam Architectural Center	64
28	New Metropolis	66
29	Anne Frank Museum	68
30	Depot Scheepvaart Museum	70
31	Bredero College School Extension	72
32	Primary School Horizon	74
33	Nicolaas Maesschool	76
34	Renovation Concert Hall	78
35	Visitor Center IJburg	80
36	Emma Church	82
37	Living Tomorrow Pavilion	84
38	School of Business	86
39	Station Island	88
40	Bicycle Storage	90
41	IJburg Bridges	92
42	Borneo Sporenburg Bridges	94
43	Piet Hein Tunnel	96
44	Evenementen Brug Amsterdam ArenA	98
45	Zorgvlied Cemetery	100
46	Bus Station Hoofddorp	102
47	Blakes Hotel	106
48	Hotel Seven One Seven	108
49	Kien Bed and Breakfast	110
50	Hotel de Filosoof (Renovation)	112
51	Hotel V	114
52	Hotel Arena	116
53	Brasserie Harkema	120
54	Supperclub Amsterdam	122
55	Noa Noodles Of Asia	124
56	Nomads	126
57	Morlang	128
58	Jimmy Woo	130
59	Plancius	134
60	Blender	136
61	Three Restaurants in One Building	138
62	Vakzuid	140
63	Restaurant De Kas	142
64	Cinema Het Ketelhuis	144
65	Cinecenter	146
66	De Toekomst, A.F.C. Ajax	148
67	Sports Medical Centre Olympiaplein	150
68	Amsterdam ArenA	152
69	Baden Baden	156
70	A-Markt	158
71	Mac Bike	160
72	Jan Jansen Shop	162
73	Rituals	164
74	Australian	166
75	Art and Fashion	168
76	Weekend Company	170
77	Fishes	172
78	Shoebaloo	174
79	Lairesse Apotheek	176
80	Villa ArenA	178

and : guide

Size: 12.5 x 12.5 cm / 5 x 5 in. (CD-sized format)
192 pp., Flexicover
c. 200 color photographs and plans
Text in English, German, French, Spanish

Other titles in the same series:

Barcelona
ISBN: 3-8238-4574-8

New York
ISBN: 3-8238-4547-0

Berlin
ISBN: 3-8238-4548-9

Paris
ISBN: 3-8238-4573-X

London
ISBN: 3-8238-4572-1

Tokyo
ISBN: 3-8238-4569-1

Los Angeles
ISBN: 3-8238-4584-5

To be published in the same series:

Athens
Cape Town
Copenhagen
Hamburg
Hong Kong
Madrid
Miami
Milan

Moscow
Rome
San Francisco
Shanghai
Singapore
Stockholm
Sydney
Vienna

teNeues